# THE
# EMPEROR
# OF SOUND

TIMBA

Amistad

*An Imprint of* HarperCollins*Publishers*

# THE
# EMPEROR
## OF SOUND

**A MEMOIR**

# LAND

WITH Veronica Chambers

The names and identifying characteristics of some of the individuals featured throughout this book have been changed to protect their privacy.

HarperCollins books may be purchased for educational, business, or sales promotional use. For information, please e-mail the Special Markets Department at SPsales@harpercollins.com.

An extension of this copyright appears on pages 223–24.

FIRST EDITION

Designed by Paula Russell Szafranski

Frontispiece: Platon/Trunk Archive

Library of Congress Cataloging-in-Publication Data has been applied for.

ISBN: 978-0-06-193696-8

15  16  17  18  19    OV/RRD    10 9 8 7 6 5 4 3 2 1

*To God, who makes all things possible*

*To my mother and father,*
*who have always*
*supported my dreams*

*and*

*To my wife, Monique,*
*for her unwavering*
*belief in me*
*and tireless giving*

# CONTENTS

# CONTENTS

# THE EMPEROR OF SOUND

# A CATALOG OF SOUND

**B**ob Marley once said, "Some people feel the rain. Others just get wet." I would paraphrase that to say, "Some people just hear noise, but for me the world is a catalog of sound." Rain, in particular, has been a constant for me. I was three years old when Ann Peebles recorded her classic R & B hit "I Can't Stand the Rain." But that song has always been a cornerstone for me. As the story goes, it was 1973 and a stormy day in Memphis. Ann, who was then twenty-six, was on her way to a concert with her producing partner Don Bryant. Ann spat out, "I can't stand the rain," and Bryant, who was at the time a staff writer at Hi Records, knew immediately that the simple words—uttered with such force and frustration—could be a powerful metaphor about love gone wrong. The two musicians skipped the concert and went back to the studio to work on the song. They were joined there by a DJ named Bernie Miller and by midnight, the trio had written what they felt in their bones to be a hit song:

*I can't stand the rain against my window*
*Bringing back sweet memories*
*I can't stand the rain against my window*
*'Cause he ain't here with me*
*Hey, windowpane, tell me, do you remember*
*How sweet it used to be?*
*When we were together*
*Everything was so grand*
*Now that we've parted*
*There's just a one sound that I just can't stand*
*I can't stand the rain . . .*

The "rain" in that song is a riff created on what, at the time, was a brand-new instrument: the electric timbale. That timbale, the love child of salsa music and the electric guitar of the modern era, gave the song a distinct opening. Before Ann even sings a word, we are there with her: sitting by a window in Memphis, listening to the rain, each drop a reminder of how lonely we are.

I used that song and a sample of rain in one of my early hits, "The Rain (Supa Dupa Fly)," the debut single of my sister from another mother, Missy Elliott. The rain in my song was different. It was the soft rain of a summer afternoon in Virginia Beach. Ann Peebles is in the hook, singing about how she can't stand the rain, but Missy doesn't really mind it. She's in her car, smoking spliffs, styling and profiling. Rain or shine, she's supa dupa fly:

*Beep beep, who got the keys to the Jeep?*
*V-r-rrrrrrrooooom!*

*I'm drivin' to the beach*
*Top down, loud sounds, see my peeps*
*Give them pounds, now look who it be*
*It be me. Me, me and Timothy*
*Look like it's bout to rain, what a shame*

Like the original "I Can't Stand the Rain," the rain symbolizes a breakup, but Missy is not crying about it. She's got an umbrella, and she knows that in this and every relationship, Missy is the prize:

*I feel the wind*
*Five six seven, eight nine ten*
*Begin, I sit on Hill's like Lauryn*
*Until the rain starts, comin' down, pourin'*
*Chill, I got my umbrella*
*My finger waves be dazed, they fall like Humpty*
*Chumpy, I break up with him before he dump me*
*To have me yes you lucky*

Quincy Jones said, "Soon as it rains, get wet." While "Supa Dupa Fly" was a dance song, "Cry Me a River," which I wrote for Justin Timberlake, was a ballad. Justin was going through some things, some heartbreak, so we put our umbrellas down and let ourselves get drenched by it. The rain in that song comes down in sheets; it's water hitting water, like the rain you hear in California when the heavens open and it pours down into the Pacific Ocean. In the video, we emphasized this by opening with the rain pouring down into a pool, so you could see it and hear it—water hit-

ting water. The lyrics rose, like a river, to match the rain in the song. Without the rushing force of all that water, these would have been just empty, sentimental words:

*You don't have to say, what you did.*
*I already know, I found out from him.*
*Now there's no chance, for you and me. There'll never be.*
*And don't it make you sad about it?*

In a business where people do a lot of talking and more than talking—a lot of bragging—I have distinguished myself by my ability to listen. Like most musicians, I live a very nocturnal life. Once I heard late-night talk show host Larry King say, "I remind myself each morning. Nothing I say this day will teach me anything. So if I'm going to learn, I must do it by listening." I listen to the artists: who they've been, who they hope to be, how they've lived, and how it comes out in their music.

I listen to the way people talk—in the club on Saturday night and in the church on Sunday morning, in the elevator of big office buildings and in the line at food trucks when it's lunchtime on a busy summer afternoon.

But perhaps most importantly, I listen to the world around me: the music that begins when the sun rises and the rhythms that don't make themselves known until after dark. Anyone who has argued with someone they love knows the limits of language: twenty-six letters in the alphabet and you can only rearrange them in so many ways. But sound is infinite and anyone who has ever been soothed by a bar of music, felt their heart leap when a pianist plays a dozen notes, felt

themselves smile at a guitar riff or tapped along to a drum-beat knows that there is a direct line between the acoustic universe and our hearts, a line that bypasses the brain and transmits truth, wisdom and meaning. The catalog of sound in my brain is my own creative Fort Knox. Each beat, each riff, each raindrop, each moan, each gurgle is priceless—a painter's palette of possibility, a fortune beyond measure.

# 1

# HOME

was born in 1972 in Norfolk, Virginia. It could be that I love the sound of rain because my hometown is surrounded by water. Elizabeth River is to the west, and north of the city you can find the Chesapeake Bay. The largest naval base in the world is in Norfolk, and so is the headquarters of one of the country's largest railways. There are sounds galore to collect in Norfolk; just from strolling by the shipyards alone, you can hear and learn the blast of the horns, the hitting of a ship door and the opening of a port window, the squeak and shake of the pulleys in the belly of the boat and the ambient hum of the big engine rooms.

Nineteen seventy-two wasn't just the year of my birth. It was also the year that Fisher-Price put out its first toy record player, and although we didn't have much, my parents got me a brand-new one for Christmas the year that I turned three. The #995 Music Box Record Player came with five plastic records. I was mesmerized by it, completely captivated by the gray plastic case

and the bright orange plastic record needle. My mother says she knew that DJ-ing was in my future as she watched the pure joy I experienced every time I lifted the needle and dropped it just so and music came rushing out of the little player.

As I got older, I felt a sense of pride that I could do this thing that my parents did: play records. I didn't know it at the time, but I was also developing a clearer connection with how music was made. It's not a far leap between being able to listen to music on your own, without the help of your parents, and wanting to create it yourself.

My family lived in a subsidized housing development called Robin Hood. My dad worked at a trucking company and my mother was a registered nurse who worked two jobs to keep the family afloat. Seems like every time I saw my folks, they were getting off work or on their way to work. I'm a workaholic and I'm proud of it. My parents worked *hard*, and through their actions, they taught me the meaning of the word.

We weren't the poorest we knew. But we didn't have much money either. And lest we ever forget that we were the have-somes living in a land of have-nots, you could step into the kitchen, turn on the light and watch the roaches scatter. That's hood. But roaches couldn't stop me from spending time in the kitchen, which, even as a toddler, I knew was a room full of music. I'd take a wooden spatula and bang it against the countertop, then I'd do the same with a metal mixing bowl and a ceramic plate. Then I'd try to blend all three sounds together. It might have sounded like noise to some parents, but my mother was always gifted at listen-

ing to the dreams and intentions underneath the typical kid things I did.

"Do you like the way that sounds, baby?" my mom would ask.

"Yeah!" I'd yell out.

"Here, try tapping this fork on this glass. See how the note sounds high? But if you tap it on a different glass, the note sounds low."

My mother encouraged me to beat on pots, drum on the table, stomp around the house. I may have a prodigious ability to collect and catalog sounds, but my mother—worn out and tired from a long day's work—gave me the space I needed to flex that gift, to play with it, to toss it around and watch it grow.

I knew from spending time at neighbors' and with cousins that a lot of parents didn't tolerate what they called noise. I look back on it today and I wonder, how did my mother have that kind of patience? How did she know that all that commotion sounded like a symphony in my head? She worked two jobs and yet she found the energy to kneel down and get on my level and tell me that I was special and that good things were going to happen for me. If I ask her now, she just pushes away the compliment. "Love is love, Timothy," she says. But that's not true. Some love shuts you down, and some love opens you up. My mother specialized in the latter.

I was a good kid, but I liked to test the limits. The old folks called that stubborn willfulness, hardheadedness. And like my grandmother always said: a hard head makes for a soft behind. I got my first spanking in elementary school

when I stole five dollars out of the glove compartment of my father's car. A guy in our neighborhood told me he'd buy me some sweets from the store if I would give him some money. So I gave it to him. Not five minutes later, my father came out of the house, got in the car and opened the glove compartment.

He asked, "Where's the money that was in here, Timothy?"

I pointed in the general direction of the store. "I gave it to him," I said. "That man promised to buy me some candy."

My father was *furious*. "You stole my money and gave it away?"

I may have been a thief, but I was a polite one. "Yessir," I mumbled.

"And why would you do something like that?"

I didn't know. The promise of candy seemed so small compared to the anger and hurt in my father's face.

My father is pretty easygoing. He's not the type to yell and scream. But I learned there were a few things you didn't do under his roof. He wouldn't tolerate lying. He wouldn't tolerate stealing. The beating that he gave me didn't hurt nearly as much as the hurt I felt knowing that I'd disappointed him and my mother. Can't say I never stole again. But I surely never stole from my parents after that incident.

Like my dad, I'm a country boy through and through. Because of our proximity to the nation's capital, it's easy to think of my home state as part of the mid-Atlantic Eastern Seaboard. But I'm here to tell you; Virginia is the dirty South down to its core.

My granddad owned a farm and I spent my early summers picking cucumbers, watermelons and tomatoes. I loved the feeling of dirt on my hands and the nonstop surround sound of farm life. The snap of fruit coming off a tree, the thud of cucumbers hitting the basket. Birds taught me more about harmony, pitch and melody than anything I ever heard on our family radio. Once a week, we sold what we'd picked at the outdoor farmer's market in town. I loved standing in the sunshine with my grandfather, helping him make money and hoping to keep a dollar or two for myself.

I may not have been wearing overalls and holding a pitchfork, but I might as well have been. That's how country I am. And I'm damn proud of it. Once you've stuck your hand in the dirt and pulled out a tomato or cucumber that you planted yourself, you have a different perspective on life. Even now, when I sit down to eat, I know my meat comes from animals on a farm. I know my vegetables were planted by someone who had to tend them for a whole season.

My grandfather was one of the lucky black folks who actually owned some land. There weren't many like him in Norfolk. And even though I was too young to really understand what that meant, I remember feeling proud that my grandfather had his very own way to make money.

**I SANG IN** church when I was a very little kid. I didn't have much of a range. My voice was clear but I couldn't hit many notes. But church was about more than singing. It was about salvation. And my mother and I didn't miss a Sunday.

Even now, when I wake up on Sunday, without an alarm, I can hear the echo of my mother's voice: "Timothy. Get up. Get ready for church. Now, boy."

By "church," my mother didn't mean one hour in and then you're out. We'd be at church from sunup to sundown. Sometimes we did a special service called Shut In, where you would literally shut yourself in the church for the whole weekend and worship day and night.

Sometimes when my mother was cooking, I would sing a little song. Something I'd heard my father play on the eight-track in the car or something we'd learned at church. My mother always encouraged me.

"I like that song you're singing," she might say. "Sing it a little louder so I can hear the words."

My mother would join me. She'd hum along and maybe even sing the chorus with me. She really got into it. "Sing louder," she'd implore as if she didn't know the meaning of the word *hush*.

Now that I'm a parent, I try to give my own kids the same attention. I have the means to buy them any amount of musical equipment, but the most important thing I can give them is my presence. Not too long ago, I released a video of my daughter, Reign, freestyle rapping while I beatboxed. It darn near broke the Internet. It was tweeted and shared on Facebook and Vine hundreds of thousands of times. It was just a father making music with his five-year-old kid, but I think what moved people, more than the music, was the connection. That's the thing about listening with your whole heart: it opens you up and connects you to people in ways you might never have imagined. My

mother listened to me. I listen to Reign. Then across the country, music lovers and parents, hip-hop fans and kids, listened to the beat *beneath* my beatbox: the way my heart pounds with love for this child who is my sun, my moon, my everything.

# 2

# A BRICK HOUSE

Mmm, this man can jam," my father would say as Rick James's distinct baritone flooded through the speakers of our stereo set. Dancing around our small living room as if it were a stage on *Soul Train*, he would tell me, "Now, this is music, Tim. You hear that bass line, it gets you right here." Pointing to his chest, he reminded me, "When it hits you here, that's real music!"

Saturday, the day before church, was my dad's day. He'd get his stereo system going and he'd play jams by his favorite artists, Rick James and Prince. To this day, when I put on one of those artists, it still hits me right here. Real music. This was my early education, and because those two artists were such innovators in their era, repeated listening to their recordings not only exposed me to R & B and funk, but also introduced me to rock, hip-hop, blues, new wave, electronica, jazz and pop. Rick James and Prince poured all of that into their music, and as a result, I do too. That's why I used Gregorian chants in Justin Timberlake's "Cry Me a

River." You can hear a psychedelic trancelike beat, the kind you find in acid house, in Aaliyah's "Try Again."

I love today's music, but the thing about those records my dad played for me is that when you heard horns, there was a guy in the studio playing a trumpet. When you heard a string section, standing right next to the singer there was a violin player, a cellist, a man or a woman plucking at an upright bass. Malcolm Gladwell talks about how the secret to mastery is putting in your ten thousand hours of training, and I know my training began in the Robin Hood housing development because I spent hours and hours listening to not only popular singers but also all of the instrumentalists who accompanied them. I'd sit and listen to the trumpets, the keys, the drums, and imagine myself right there, in the studio with them. I knew that for most folks all of the instruments blended together, but for me, the joy was separating them in my mind, then layering them back together. You know the way some kids like to take apart a toaster and put it back together again? That's the way I was with songs. By the time I was nine or ten years old, I could pick out each instrument on a track and I could follow along, like a conductor in training, as it entered and exited the piece. Today, not many artists can afford to have live musicians recording in the studio, so you sample it. And when you rely on samples for your entire musical foundation, you're only getting a *sample* of the greatness inherent in the music.

Rick James's first album, *Come Get It!*, was released by the Gordy imprint of Motown Records in 1978, when I was seven years old. My father loved that album. And so did I. Although it wouldn't be his most popular record (that would

be *Street Songs,* released in 1981, which featured his hit single "Super Freak"), *Come Get It!* was in constant rotation in our house. Hard-line Bible-thumpers would have taken issue with the fact that we'd be playing overtly sexual music like Rick James on a Saturday, and then we'd spend all day on Sunday in church, moving and grooving with the choir. My mother swayed right along with Rick James on Saturday mornings, as she cleaned the house. For her, and so for me, there was no contradiction.

The big hit on that album was "Mary Jane." As a kid, I had no idea it was a euphemism for marijuana. What I noticed was the way the women's background vocals were layered perfectly with the tight bass line, the strings and how unusual it was to hear the pitchy clarion call of a flute on a club song. I was surprised that a flute could make such a funky sound. I began to understand that instruments can do anything. As people, we often grow up in one neighborhood, go to school or away to college in another and then live our lives among one type of person, doing one kind of thing. But Mozart and Alicia Keys can play the same instrument, hundreds of years apart, and bring entirely different points of view to the same eighty-eight keys. Not too long ago, jazz violinist Regina Carter was given the rare opportunity to play an instrument called the Cannon, the violin that belonged to one of the most famous violinists to ever live, Niccolò Paganini. Since Paganini's death in 1840, the Cannon has been kept in a vault, where only a few chosen musicians have ever gotten a chance to play it. Many took offense at the idea that a black girl from Detroit who plays jazz music, which in the classical world is as rad-

ical as hip-hop, could be allowed into this sacred circle of musicians who got to play Paganini's violin. But as Carter herself said, "[Some believe that] jazz is a lesser music than European classical music. Jazz is a music that's improvised, but when you look back at Paganini's history and the era he came out of, he was a baroque musician and baroque musicians improvised." In the lineage of true music, music that grabs you by the chest and doesn't let you go, we're all connected.

As poor as we were, my mom saw my love of music and found a way to get me violin lessons. I can't play the violin today but I remember holding it up against my chin when I was a kid, wondering how I could make that instrument sound like it belonged on a Rick James song. Rick James has been called the pioneer of "punk funk," and that would have an influence on me as I inched my way toward making music of my own.

Similarly, Prince's self-titled sophomore album was as real as it got. Even at eight years old, I knew this man was doing something special. The opening chords of his hit single "I Wanna Be Your Lover" were, to me, the musical equivalent of being handed the keys to Willy Wonka's chocolate factory. I binged, like a kid in a candy store, on the techno-inspired keyboards, the driving drumbeats and Prince's unusual falsetto.

My mom got me this plastic guitar. It felt so good to hold it in my hand and play along to my dad's records on a Saturday afternoon. There's an interlude on "I Wanna Be Your Lover" where the electric keyboard and the electric bass are just going at it. Sick. I played air guitar to that interlude

again and again and again. When my dad first played me "Another One Bites the Dust" by Queen, the opening—a guitar lick and a sick drumbeat—was unlike anything that I'd ever heard. That song, more than any other, made me wish my plastic guitar were real. It also made me begin dreaming about owning a drum set. Talk about grabbing you by the chest—that song has actually been used to train medical professionals in CPR by the British Heart Foundation. "Another One Bites the Dust" has 110 beats per minute, and when you give CPR, they recommend 100 to 120 chest compressions a minute. Incredible, right?

Then, finally, my dad would flip on "Da Ya Think I'm Sexy?" by Rod Stewart. If you haven't listened to that song in a while, then you should dig it up. The genius of the instrumentation is unparalleled. It's got that techno-synthetic keyboard and a light layer of strings over the bass line. Yeah, the vocals are in-your-face and aggressive. But like every truly great pop song, it's got all the elements you've heard before, lined up in a way that you've never quite heard before. From the drum solo to the horns and violins, that song picks you up and doesn't let you go until the very last guitar lick.

I eventually did get that drum set I'd been dreaming of since my father first played Freddie Mercury and Queen in our tiny apartment in Virginia. One of my favorite childhood pictures is of me, sitting at my kit, drumsticks in hand, cowboy hat on my head. There used to be a comic book series about a character named Richie Rich, the richest kid in the world. With my Fisher-Price record player, my plastic guitar that I could play imaginary rock riffs on and my real-life

drum set, you couldn't tell me a thing. We may have been living just above the poverty line in the Robin Hood housing complex, but surrounded by music—both my father's records and the instruments that I owned—I felt like the richest kid in the world.

# 3

# SCHOOL DAZE

I loved music. I wanted to listen to it and make it all the time. But at eight years old, I had a full decade ahead of an environment I never excelled in—school. While my mother and father encouraged me to make a joyful noise, both in church and out, the teachers at school had another perspective entirely. It was always my name followed quickly by an admonition to pipe down:

*Timothy, stop making all that noise.*

*Tim, stop drumming on your desk and take out your spelling book.*

*Timothy? Are you the one making all of that noise in this here classroom? Please stop.*

*Tim. This is not a music class. Stop humming and focus on your class work.*

*Timothy Mosley, if I have to ask you one more time to stop tapping your foot, you will get a fast pass to the principal's office.*

My mind was always somewhere else. Most of the time, in school, I was busy thinking about how I could and would be dif-

ferent. That's what I always wanted. I didn't even fully know what that meant or how it would manifest. But I knew I wanted to be different. More than average, which is what I was afraid I might be. A lot of people look at musical artists and all they see is ego: the braggadocio, the super-size confidence that it takes to say "I'm number one" or "I am the greatest." But this is the thing: most of us spent all of elementary school, all of junior high school and all of high school never getting those pats on the back and the metaphorical applause that comes with good grades and high test scores. Very few schools give kids points for being creative, for being gifted at something you can't measure with a spelling test or a math quiz. So we grow up, we musical misfits who have the drive and the skill to become stars in our fields, being told that we are less than average. In order to survive that, we develop a "One day I'm going to show them" attitude. And to truly nurture that drive, that skill, when the world has always been down on you, you've got to puff yourself up. You've got to convince yourself that deep down you are more than average, you are better than. So you have the image of those who've underestimated you paired with all the willpower and confidence it takes to make it, and it might look like you've got a big head, you're out of control, you think you're all that. But that's not the case. You're just a person wanting to be seen and be valued for the gifts you've brought into this world.

I know because I remember watching my mother's eyes as she scanned my report card, her forehead creased with worry. I knew she was concerned about my schoolwork. I kept trying to do better, to be the kid that the teachers

wanted me to be. But I was bored and distracted, and focus, at least back then, was not my strong suit.

"'Timothy spends all of his time talking about music,'" my mother read aloud. "'He is not giving his schoolwork one hundred percent and his grades are a clear example of this.'"

She handed over the report card to my father, who continued reading aloud: "'Timothy consistently makes noises—'"

I took offense at that. "I make music, not noises!"

My father shot me a withering glare and said, "I am reading, Timothy. You'll get your chance to speak." Then he picked up the report card and read, "'His grades will continue to suffer if he doesn't begin paying attention in class.'"

My father sat down on the sofa, holding my report card in his hands. I could feel the weight of the day plop down next to him, could practically see all the bullshit he'd taken and all the insults he'd let slide spill over from his pants pockets as if they were marbles he'd been carrying around that he could finally let go.

"I know you like music," my father sighed. "That's fine. I do too. But music won't pay your bills, Tim. You need to put school first, so you can get a decent job. I want what's best for you. You're my son. But I'm worried about what this singular focus on drums and guitars is doing to your studies. School has to come first. I'm not saying don't do music. I'm saying school has to come first. That's the rest of your life on the line there, son. Music is just a hobby."

I looked to my mother. She didn't say anything. She didn't have to. I knew she believed in me. I don't fault my father. He was saying what he believed to be true. If all the breaks in my career hadn't come, if the stars hadn't aligned

just so, he would have been right. Whatever job I'd qualified for after school would have been how I earned my living and supported my family. Music would have been just a hobby. But I had to hold fast to my dream. Thomas Edison was famously chided for his daydreaming—one teacher even called him "addled"—and he went on to become one of the finest inventors the world has ever known and is credited with inventing the lightbulb, the motion picture camera and, my favorite, the phonograph. Benjamin Franklin was a diplomat and an author, a scientist and an inventor. He was one of the founding fathers and signed the Declaration of Independence—and he was a high school dropout! We all learn in different ways and if you have something you're passionate about, if you're committed to being an eternal student in your field of choice, then don't measure yourself by other people's benchmarks. Thoroughbreds wear blinders because what's going on with all the other horses doesn't help them at all. Run your own race.

Music had taken ahold of me, and I moved from the punk funk of Rick James and Prince to the rock-rap rhythms of Queen to the pioneering artists of hip-hop. My class spent a lot of third grade learning fractions. I spent most of that same time trying to pinpoint the break beat to Chic's "Good Times" that was sampled on the first-ever rap hit, "Rapper's Delight" by the Sugarhill Gang.

# 4

# TWO TURNTABLES
# AND A MICROPHONE

**M**y grandmother lived in Virginia Beach on Post Oak Drive. Her town actually bordered Norfolk, my town. Looking back, I can see that where we lived in Norfolk was more hood and my grandmother's area was more solidly middle-class. As a kid, I thought my grandmother's neighborhood was the most beautiful one in the world. I loved it there. Stand-alone houses with driveways. No neighbors knocking on the ceiling or the wall telling you to quiet down. As I got older, every time I visited my grandmother, I felt deflated when I got home, like, "Oh man, this is where we live?"

Grandma's house was special because it was also where I got to spend time with my two uncles, Marcus and Eric. We did everything together. They were closer in age to me so they were more like brothers or cousins. We spent so much time playing hide and seek, riding bikes, playing kick the can and just being boys that I hated it when I had to go home.

I never liked being an only child. Every year I'd ask my mother to have another baby and even though I was small, I could see that they could barely afford to take care of me. I was so happy the year my little brother, Garland, was born. No toy, no gift, could have been more important to me than having him in the world. All my life, I'd felt like some part of me was missing. I was shy. Quiet. Inward. Then along came Garland, funny from the start, witty and smart from the start. And it was like I'd found my missing piece.

When I was eleven, my mother gave me some news that would again change my life. She told me we were moving. My first reaction was panic: a new school meant new kids to befriend and new teachers who were sure not to get me.

"Where are we moving?" I asked.

My mother smiled. "Virginia Beach, close to Grandma's house."

I jumped out of my chair and let out a whoop the likes of which I don't think my mother had ever heard from me. Good-bye, Norfolk. Good-bye, Robin Hood housing complex. I thought we were moving on up like the Jeffersons. Well, we weren't the Jeffersons. But we did move to a nice little place in a community called Salem Village. Better than Robin Hood for sure. At least the houses were clean and there weren't roaches everywhere. There wasn't open drug dealing and the people were poor but hardworking. My mother always said, "We may not have a lot of money, but the biblical foundation of our family will keep us strong." But I think she worked all those jobs, got us to a slightly better place, because she knew that even the Bible might not protect her sons if they were living in the

projects, and every day, me and my little brother, Garland, were in harm's way.

I remember that we couldn't afford furniture in the whole house. We only had furniture in the bedrooms—the living room was practically bare. Didn't bother me none. Felt like I'd died and gone to heaven.

One afternoon, I was outside playing with my friends when my dad called me in.

"Timothy," his voice boomed. "Get in here."

I just knew I was in trouble for something. But I couldn't remember what I might have done. I started going through my day, looking for moments when I might have tried to put one over, but I kept drawing a blank. I was no angel, but the day's roster of mischief was completely clean.

"Yes, sir?" I said when I got into the house, breathless from running.

"Go to your room."

I remember thinking, *Man! It must be really serious if he's sending me to my room straight out the gate.* But I couldn't think of anything I'd done in recent memory that was beating-worthy. I was sure I would figure it out soon and that there would be lots of pain to go along with the revelation.

When I stepped into my room, I nearly fainted. Set up right by my bed and dresser was a brand-new set of Gemini turntables. I couldn't believe it. My father was always stressing the importance of school, reminding me that music was a nice hobby but I needed an education and a practical plan to make a living. It shook me to the core to realize that all of his lecturing didn't come from doubts about my ability, just concern for my future. He believed in me, and although he

never said the words, those turntables more than said it for him.

That afternoon, DJ Timmy Tim was born. I started buying records and teaching myself how to blend them together. It was my plan to get work DJ-ing local parties. I wanted to prove to my father, as soon as humanly possible, that his investment in me was worth it.

In a way, my dad was the first DJ that I knew. Not in a club sense, but in the old soul radio sense. His Saturday afternoon music sets moved and inspired the whole family. He knew just what songs to play to get us wanting to dance. That was my goal when I started: to find the right mix of music that would make a party full of people hit the dance floor and stay there, shaking what their mothers gave them, until the very end of my set.

When I closed my eyes, I wasn't a shy kid playing around on the turntables in the bedroom he shared with his little brother. To the contrary. In my imagination, my bedroom was a party place, filled with screaming fans dancing to Run DMC (*This speech is my recital / I think it's very vital / To rock a rhyme / That's right on time . . . / It's tricky, here we go . . .*). In my mind, the crowd was grooving to the music of their favorite artists—Mantronix into Run DMC into LL Cool J—but I was making it happen. The order. The blend. The beat. The mix. That was all me.

I was particularly into Mantronix. I can't overstate the effect that their music had on me as a young DJ. Mantronix was a hip-hop and electro-funk duo with a DJ and an MC. They were into layering eclectic sounds that most hip-hop producers had yet to discover. I've never been interested in

the status quo. To me, there's no joy in music that merely seeks to fall in line. Mantronix gave me permission to be into hip-hop, but also to bring something different to the game.

DJ Kurtis Mantronik (aka Kurtis el Khaleel) was a Jamaican-Canadian producer who became inspired by early electro-funk tracks like "Riot in Lagos" by Ryuichi Saka-moto, who back then was part of a Japanese electro group called Yellow Magic Orchestra. When I look back at my early work, I realize that trying to chart my influences is like trying to pinpoint the origin of a cell phone signal in those movies when the bad guy is using a scrambler. The signal ricochets all over the world, from Virginia Beach to Kings-ton, Jamaica, from Kingston to Toronto, from Toronto to Tokyo. And it's still moving. You couldn't box it up and put a label on it if you wanted to, no matter how hard you tried.

I knew that I wanted to appeal to a lot of people with my DJ style. I didn't want to just raise the roof for hip-hop fans or bring in the funk, bring in the noise for people who loved R & B. I was inspired by Mantronix because I wanted to blend sounds together in surprising ways to create music and sets that would be a little familiar to everyone, but also have that element of being brand-new at the very same time. This would be integral, later, to my work as a producer. In the music business, which loves to label you, they say I'm an artist who "crosses over." But to my mind, I make music that I love and everyone who enjoys it crosses over to *me*.

After my dad got my turntables, I started looking for small parties to DJ. School parties, basement jams and the like. There weren't a ton of opportunities, but I was per-

sistent, so I started to book a few gigs. In the summer, a local community center would host a party for the neighborhood kids, so I finagled my way onto their DJ roster. Those early, low-pressure gigs helped me test out my skills and hone the basics.

For the DJ, it's all about the art of the blend. You can't play a record, wait for it to end and then pop another record on the turntable. The floor would empty out immediately. You need to listen to one record in your headphones, then figure out the perfect time to segue into the next. It's not easy to learn. I taught myself and I got pretty good at it.

Once I mastered the art of mixing and blending other people's songs, it was a natural next step to making music of my own. I borrowed my first keyboard from a guy named E. It was an EPS (Ensoniq Performance Sampler). That sampler was relatively easy to use, geared toward consumers rather than professionals. It was a thirteen-bit sampler that allowed you to load up to eight instruments at a time, with another eight on standby. This was heaven for me. I loved the idea of layering sounds like Mantronix, and now I could layer the instruments I wanted to as well. *Heaven.*

I began creating music because the music I was playing was always missing something I wanted to hear. I loved hip-hop. But it wasn't giving me the same thump-to-the-chest feeling of those Rick James and Prince songs that my dad played on repeat when I was a kid. Those songs formed my musical backbone—strings, horns, layered drumbeats. I wanted to hear music that sounded like *that*. So I started to make it.

When I first met Pharrell, he had dreadlocks and wore a

backpack at all times. Like the rest of us, he was just getting started in the game of love, and I remember that he cut his locks when this girl he was crazy about broke up with him. We'd actually known each other as very young children. Our grandparents went to the same church and there was always talk that we were actually distant cousins.

Pharrell and I had a class together when we were in junior high and we both used to beat on the desk. I used to do the drum roll with my fingers. I remember Pharrell saying, "Yo, teach me how to do that." It's something he still does. Me too. But whenever I see him in a video or on a show, doing that drum roll, I get this huge smile on my face because I know we're part of the same tribe: the music *lives* in us and we can make music with our hands, with our mouths, beating against any surface you give us. Pharrell and I have such a bond because we grew up together and somehow managed to keep that quality that was in us from childhood for the rest of our lives. Pablo Picasso said, "Every child is an artist. The problem is how to remain an artist once he grows up."

# 5

# TROUBLE MAN

Larry Lyons had moves. I met him at a house party where I was DJ-ing. He was the type of guy who danced so hard that he got everyone in the place hyped. After a while, we became friends and he became my dancer. He would position himself next to the DJ platform where I was working and dance to the music. Kind of like my hype man.

In the early stages of hip-hop, a dancer was essential to your growing rep as a DJ. If your guy didn't know what he was doing, if he wasn't hyped enough, his energy might bring down the crowd. Larry never failed to make sure that when I spun the tracks, the dance floor stayed pumping until I was ready for everybody to go home.

Those were the pioneer, horse-and-buggy days of hip-hop. The beats were new. The artists were new. And part of what drove the popularity of the music were these dances that everyone wanted to

do. Think Kid and Play in *House Party*. Think the Humpty Dance and the Running Man. Disco and rock were different eras in dance. People did their own thing on the dance floor (with the exception of a dance like the Hustle). But the hip-hop era brought to the fore *dozens* of dances that teenagers, coast to coast, learned, perfected and put their own spin on. Honestly, I don't think the country had seen a phenomenon like the dancing in my era of hip-hop since Chubby Checker had everybody doing the Twist. Although the music would eventually find its shadow side in gangsta rap, the early days of rap music were fun, wholesome even.

I had started getting a few really small paying gigs. With my pops's blessing, I used the money to add a bit of equipment to my turntables and my low-budget Casio keyboard.

One night as Larry and I prepared for a party, I said, "Yo, Larry. We need to get this mix right tonight. I heard this party is going to be packed."

He shrugged. "Ain't no thing but a chicken wing, bro. You never have a problem keeping the crowd live."

I shot back, "But you can't get comfortable. *I* can't get comfortable."

No matter how many times my set ended with the crowd being a happy, hot, sweaty mess, I still worried about the next party.

"What's on the playlist?" Larry asked.

I dug inside my milk crate of vinyl records and began pulling albums out.

"I'ma start with 'Rock the Bells' and then go right into 'Peter Piper.'"

"That's good," Larry said, rubbing his hands together.

I pulled out more records, stacking them on top of each other.

"Then I'll play some more Run DMC, a little LL Cool J and some of that new Mantronix club music."

Larry looked at me. "And you're worried about what? The set is solid. Let's do this."

I was fifteen years old and on my way toward a dream and a life that would be bigger and brighter than I could ever have imagined.

**I WAS IN** the tenth grade and I'd gotten a little job at the Food Lion, a local supermarket, bagging groceries. I always kept a little piece of a job to supplement my DJ work.

Pharrell walked into the store and said, "DJ Timmy Tim. Everywhere I go I hear your name."

I smiled. Pharrell was becoming a multi-instrumentalist who was almost like a Prince in the making.

"I hear a lot of good stuff about you, too," I told him. "What are y'all getting into?"

He told me he had a group with these cats named Chad and Hugo, dudes he'd met at band camp. I told him I was doing parties here and there, trying to line up that DJ work.

"You trying to get in the studio?" he asked. "What kind of equipment do you have?"

I told him, "The regular stuff. Trying to get my hands on an ASR-10."

He nodded. "Me and Chad want one too. We know a

dude who lets us borrow his. We've been trying to learn how to make some beats." Then he asked me the million-dollar question: "Yo, Tim, you just trying to DJ or do you want to make music too?"

I shrugged. "Whatever happens is cool with me."

Pharrell said, "Well, I'm trying to get on. I want a track on the radio. You let me know when you're ready to go that route."

I promised him I would and we shook hands on it.

As Pharrell started to leave the store, he doubled back to tell me something. "You really need to start thinking about taking this music thing seriously," he said. "You know, Virginia Beach. It's small around here. Everyone's talking about you. You're a big fish in a small pond. Take advantage of it."

I just nodded and said my good-byes. But it was a conversation that I would replay in my head, from time to time, as my ambition began to take root and grow. Pharrell was more focused than I was at the time. I didn't yet get that music could be more than a hobby.

Today Pharrell is an internationally known artist and producer. He's made a lot of amazing music, but with his song "Happy," he entered the realm of forever music. Like the Beatles' "I Want to Hold Your Hand," someday we'll all be dancing to "Happy" at our grandchildren's weddings. It's one for the vaults. Flawless and timeless.

That summer, when I wasn't working at the Food Lion or DJ-ing at my little gigs, I was sitting somewhere with my friends Caleb and Joe, drinking. I'd finished my second year of high school and I'd discovered the joys of cheap liquor.

We drank Boone's Farm, Old English, St. Ides (aka Crooked I) and Thunderbird. Whatever we could get our hands on. Not surprisingly, I got into my share of scrapes during this time. We stole pizzas from Little Caesars, got into fights with other boys from different neighborhoods and of course spent lots of time on the beach and boardwalk, hanging out.

The more they drank, the more Caleb and Joe scrapped. And as the summer went on, I found myself playing ref on the regular.

"Why you always talking shit?" Caleb asked Joe one night when we were sitting around a vacant lot drinking.

"Don't start, Caleb," I said, turning the bottle to my lips and shuddering as the alcohol hit my empty stomach.

"You tell *him* not to start. He's always getting on my nerves," Caleb growled.

Just as I had learned how to read a crowd when I DJ-ed at a party, I knew how to read the mood when I was hanging with my fellas. I saw something in Caleb's eyes that night that was different. First of all, he drank more than usual. Never a good sign. But on top of that, he kept patting his pocket as if he wanted to make sure that whatever he had was still in there.

Before I could even talk Caleb out of whatever he was thinking about, he and Joey were at it, rolling around the parking lot, fighting like two pit bulls who'd been kept chained up for days. I had seen them fistfight before, but this escalated in an instant. Caleb pulled out a razor. Joey had one too. These dudes were trying to slice each other and I wasn't trying to get in the middle of it. But something had to be done before blood began to spill.

"Come on, y'all," I said, trying to break up the fight while staying out of the range of the swinging blades. "Break it up," I yelled at the top of my lungs. I think the sound of me being so loud, when I was usually so quiet, startled them, and they finally separated, both of them out of breath, each of them still mumbling about kicking the other's ass.

We weren't bad kids, but we were at that age where we were beginning to get bored of our strolls on the beach. We didn't have the money for a flashy car or to really impress a girl, so most nights we made our own fun. Unfortunately, that kind of cheap fun usually involved alcohol and weed. Which led to dumb, senseless stuff like Joey and Caleb's razor fight.

I've seen enough violence, and been smack-dab in the middle of enough insanity, to be dead a few times over. I had parents who cared about me, two parents at that—no missing-dad action in my story. Yet I still felt lost as a teenager, roaming the beach with my friends. When I talk to kids today, I urge them to be like Pharrell and have a vision, a plan, for their future. Even if it doesn't turn out exactly the way you thought it would, that vision will keep you out of a lot of trouble that could make it so you have no future at all. I tell the young music fans I meet the same thing I tell my kids: who your friends are, what you do in your free time and where you hang out are all going to have an impact. Choose your friends wisely and watch where you find yourself. You want to feel like you're rolling with the A team, not with the dudes who need constant minding and rescuing.

I understand, however, that once you get caught up with a certain crowd, all the advice in the world feels easier said than done. Just a few weeks after the razor fight, I was DJ-ing at a party near a place called the Plaza. Everyone started screaming that there was a fight in the lot behind the house. I ran outside and saw my boy Joe bent in half on the ground.

"Yo!" I yelled out. "Get help. Something's wrong with Joey!"

Caleb and my other friends ran over and we turned Joey over very gently. He was stabbed badly in the chest and the blood was pouring out of him.

"We gotta get him to a hospital," one of my friends said. We picked him up and somebody with a car drove us to the hospital. There were a lot of questions in the ER about what had happened, but we deflected and said we didn't know, that we thought Joey had been jumped and robbed in an alley. I nearly started gushing and crying when the doctor said that Joey had lost a lot of blood but he was going to live. They kept Joey overnight and then he was released. But we didn't learn our lesson. It didn't take long before we were back to our old ways. More fights. More drama. More violence.

We were drinking in our favorite vacant lot when Caleb nodded to some dudes we didn't know. "What are they looking at?" he asked in universal hood language for *I'm bored/ I'm angry/I'm itching for a fight and I'm going to scratch that itch whether you like it or not.*

It was just a few months after Joey had been stabbed, and I remembered how I'd had to hold back the tears when I

thought my boy was going to die. And I remembered how I'd nearly sobbed again when the doctor said he was going to live.

"Don't start," I said to Caleb. "I'm not trying to get into it with *nobody.*"

"*They* started it," Caleb said insistently, willfully refusing to use the sense that God had given him. "They obviously got beef."

We ended up squaring off with those dudes and having a fight. At that point in my life, a fistfight was nothing. You can walk away, or even hobble away, if it's just a fistfight. But as was becoming increasingly common, there were more than just fists involved. I heard Caleb scream out and drop to the ground. Caleb had been stabbed.

"What do we do now?" one of my friends asked.

"We get him to the hospital!" I said, helping Caleb to his feet.

"They're going to want to know what happened," Joey said, panicking. No doubt he was experiencing a painful case of déjà vu.

I rolled my eyes. "We'll tell them the same thing we did when we dropped you at the ER. He was robbed."

Caleb's wound was even worse than Joey's. For hours, it was touch and go. The knife he was stabbed with was old and rusty and the doctors were afraid he'd get tetanus from the wound. But he recovered.

Nearly losing his life didn't teach Caleb anything but how to make more trouble for himself and, in the process, our crew. Now that he'd been stabbed, he decided the only way to *really* protect himself was with a serious weapon. At that

point, I should have checked out of the friendship. But I was fifteen and I thought that being a friend meant being loyal to the end. I didn't live in the Robin Hood housing projects anymore, but I still lived by that creed. One for all and all for one. No matter how dangerous or senseless that was.

# 6

# THE CODE

We called it the Code. Our friends were our family, and it was expected that you stood by family until the end. I wanted to back away from Caleb. Put him on the slow freeze, dial back and duck out until we were no longer hanging out all the time. But *that* was completely against the Code.

One night, after Caleb got the gun, we went to a backyard party near Salem Village. We had been drinking before we got there and Caleb had that reckless, tipsy look in his eyes. You could always tell if something crazy was going to be jumping off when Caleb had that wild look.

I tried to talk sense to him. "Caleb, don't start any trouble tonight. Focus on the girls. We're just here to have some fun and meet some girls." My voice was stern and my face was serious. Sometimes, I could influence him if I caught him early enough, if I used my voice and expression to let him know that I wasn't having it. When it worked, something in Caleb would visibly relax

and we would genuinely have a ball. When he wasn't on the edge of setting things off, there wasn't anybody funnier or more charming than Caleb. This was not one of those nights.

"Yo! Fuck you!" I heard someone yell. I whipped around to see Caleb arguing with some kid I didn't know. I knew that there was still a big square of gauze and tape covering the knife wound on his chest, and I wanted to reach out with my fist, punch him where I knew it would hurt and say, "Fool, at least recuperate before you get stabbed again." Then I saw the bulge at the side of his waist and I knew that things were worse than that even.

The circle around Caleb and the kid he was fighting widened and Caleb was right in the middle of it all. Joey and I were tugging on and talking to Caleb, trying to get him out of the gladiator's ring before he made a mistake that we would all regret. Once I got close enough to grab him, Caleb wrestled away from me and took out his weapon.

The crowd began screaming and everyone scattered. We all ran like hell and I wasn't even trying to save Caleb. If anyone told the cops about what he'd done there'd be some serious consequences. No one was hurt, but his action was enough to get you some hard time in the county jail. Joey and I had been standing close enough to Caleb that an eyewitness could very well have thought we were the ones who'd been brandishing the weapon.

Once I'd run far away from the house, I slumped down to the curb and tried to catch my breath. I could feel my heart pounding and I had a feeling I'd never experienced before. I was so grateful to have my life. Caleb was my boy but enough was enough. I had to figure out a way to keep my distance.

I gave up drinking in vacant lots with Caleb and Joey and I focused on my parties and staying out of trouble. I was DJ Timmy Tim. I just wanted to make people dance.

**A FEW MONTHS** later, my hard work and focus began to pay off. I was sitting at my parents' house with my dancer and DJ partner, Larry. I opened the box in front of me and for a moment, both Larry and I stared in amazement. A double cassette recorder. It was a huge deal. I was now officially in the mix tape game. I could now copy my tapes and give them out at parties as advertisements. I could also make pause tapes: playing one song and recording another song on top of it. In the 1980s, the double cassette recorder was at the center of the DJ universe and I finally had my hands on one, with a little help from my mom and the long hours I'd started putting in at the Food Lion.

Pharrell had started a group called the Dead Poets Society. They were an alternative, backpack rap group, similar to De La Soul and A Tribe Called Quest. Now that I wasn't wasting my nights drinking forties and babysitting Caleb, I had decided that I wanted to form a group too. I recruited Larry, Pharrell, my boy Melvin, Chad, Mike and my new girlfriend, Tameka. We called ourselves Surrounded by Idiots. Larry danced and rapped. Pharrell rapped and produced. Melvin, whose nickname was Magoo, rapped as well. Chad worked on the music. Mike sang the hooks and Tameka rapped. (Tameka was a dope rapper. I don't know what she's doing today, but she was *dope*.) I was the DJ and the producer.

We were officially a group, and we spent hours and hours at my house, playing around with sounds and making music. That group was a crash course in sound engineering for me. It was like hip-hop academy, and I was getting the education of my life. We even had a few songs that I think would still hold up to the standards of today. We had this one joint called "Katherine, Oh Katherine" and another called "Skullcaps and Striped Shirts." They were playful records, based on people we knew from around the way. For who we were and the equipment we had, I think we did a great job. I wish I still had those tracks, but they were lost with so many of my teenage things.

It was during this time that I began my transition from DJ to producer. We recorded as many songs as we could, hoping that the local stations might give us a shot. The big hip-hop station at the time was 103 JAMZ. We sent our songs to the DJ there every week but they never got played. But we never got discouraged. Every rejection just confirmed the wisdom of our group name. If other people couldn't see our talent then we were right. We were surrounded by idiots.

I got a job busting suds at the local Red Lobster. I worked in the kitchen, washing dishes, and I *hated* it. But it was a job. It helped me buy things like records and equipment that I needed to continue making better and more sophisticated music. I viewed it as a sacrifice, a necessary evil that would help me do what I loved most and keep me away from the county jail. I had enough sense not to sell drugs or do anything that would get me into serious trouble. I wasn't built for that type of risk and you can't make music from a jail cell. Plenty of the neighborhood drug dealers were guys I'd

grown up with; we'd nod hello and go our separate ways. I always knew that if I wanted to get on the block and flip a few bags of coke, I could opt in pretty easily. But that life just wasn't for me.

I worked in the kitchen with my boys Tyree and Greg Black, and we tried to make the best of a crappy job. Taking out the garbage and cleaning off plates wasn't the easiest way to make $3.25 an hour. Having friends there made it more bearable. That's the thing about me. I've never been too good for *any* job. I've always managed to keep a way to make some change. A lot of rappers brag about being a hustler. I was always a worker. I would do what I had to do to keep something jingling in my pocket. I got that from my dad, and by the time I was sixteen, I knew full well why he'd spanked me for stealing that $5 out of his glove compartment. I knew how hard he'd had to work to earn that money. I was never too lazy or too proud for an honest day's work. I had friends who didn't want to do a minimum-wage job, but at the same time they never had any money and they seemed to be okay with that. I always felt that I could be poor, but I couldn't be broke. I'm too proud not to work.

At Red Lobster, I had just one problem. My hothead friends. I'd disentangled myself from the Caleb-and-Joey drama but now here I was—new place, new dudes, same referee stripes painted on my back. One night, a "friend" came into the back area looking for another guy. It was closing time and I was just about ready to punch out for the night.

"I got something for your boy," he said.

I rolled my eyes and asked, "What you got?"

He smirked and said, "I got this."

Before I could even make out what was in his hand, I heard a loud *pop!* It was a gunshot. The man had pulled out his revolver and the gun had gone off accidentally.

"Oh shit! Tim! My bad!" He said, still holding the gun and looking at me in shock.

I realized my arm was hanging slack at my side and there was a burning sensation from underneath my left armpit all the way down to my wrist.

I turned and could see the blood pouring out of my arm. The burning sensation subsided and I had no sensation at all in my arm. My left arm was completely paralyzed.

Who gets shot at Red Lobster? The whole thing was so ridiculous, I might have laughed if it hadn't been me. I had tried to do the right thing. I'd broken the Code and had distanced myself from Caleb. I'd put down the forties and had gotten a job. How was it that I *still* ended up getting shot? It was as if there was a bullet out there with my name on it and it was going to find me, no matter where I went.

At the hospital, my mother was a wreck. She asked the doctors if I was ever going to be able to use my arm again. The doctors told her they didn't know. They were afraid that they'd do more damage if they tried to remove the bullet, so they were going to leave it there, wait and see.

My mother, churchgoing woman that she was, just about lost her mind. "What do you *mean* you are going to leave a bullet in my son? What do you *mean* you are going to wait and see?"

The doctor took a deep breath and repeated his words. He said, "Your son is going to have that bullet in his arm for the rest of his life. We'll do more harm than good if we try

to extract it. He might be permanently paralyzed if we hit the wrong nerve. Our best bet is to leave it there and let the arm heal."

My mind was on one thing alone: music. What kind of DJ was I going to be with one arm? I felt like my whole life, everything that had given me joy, was being taken away from me. For seven months, I had no use of my left arm. All I could think was, *If I can't DJ anymore, what am I going to do?*

I thought, *You know what? This can't hold me down.* The doctors had given me a few weeks of physical therapy but my arm was still paralyzed, so they stopped the therapy. They said, "Time will tell." I just rolled my eyes because I knew that the devil loves an idle spirit. I was going to work my arm, every day. If I got the feeling back, great. If not, then I was about to become the best one-armed DJ the world had ever seen. Every day, I picked up my paralyzed arm and rested it on the table with the turntables. I began using my shoulder to scratch. The pain was excruciating but I refused to give up. All I knew how to do was DJ. I wasn't going to give up the one thing that had brought me so much joy. Just the pain I went through to restore feeling into that one hand—I wouldn't wish that on my worst enemy.

**THE NEW SCHOOL** year started with a party at our high school. It was one of those perfect late-summer nights. The party was outdoors, my favorite kind. Our whole Surrounded by Idiots crew came through and we performed all of our original songs. Then I spun records with my elbow, playing songs that kept people dancing and happy.

By senior year, I'd given up the heavy drinking I used to do with my buddies. I didn't even smoke weed anymore. I had no need for an artificial high when I was in my element. Seeing folks with their hands in the air, dancing to the sounds of DJ Timmy Tim, was more than enough of a high for me.

I wasn't an angel. I could still be the typical teenager, looking for trouble. But I had removed myself from the really dangerous situations that could have put me on another path altogether. Music saved me from running with people who seemed attracted to violence. I had something else to do.

As accomplished as I was beginning to feel as a DJ, I was still in the fledgling stage of making beats. With my double cassette recorder, I had a way of spreading my beats out to local rappers and singers who were looking for backing tracks. One day, Magoo (my friend Melvin) came up to me holding one of my tapes.

He said, "I want you to meet this girl from a group called Fayze."

"Why, what's up?"

"She's dope," he promised. "Her group is making a demo and I want you to hear her stuff."

It was exciting to hear that a local group was making an official "demo" as opposed to just making a bunch of songs. Even though there was no real difference in the process, when you called it a "demo," it became something official, something accepted as part of the record business. The terminology brought it closer to being a real professional audition piece as opposed to something you were just doing as a hobby. A demo was a project you were going to submit to

record labels, and that was a whole new level of the business for me.

"Tell her to come by the house whenever," I told Magoo.

It was around this time that I decided we needed to streamline the Surrounded by Idiots lineup. Pharrell was busy. He was still playing in the high school marching band, and he and Chad were in the studio with their own music and doing their own shows. Add our group to the mix and I knew how thin Pharrell was stretched. I invited him to come over one afternoon to talk about it and he told me, straight up, "I think I need to stick with what me and Chad are doing."

"I can respect that," I said. "We just needed to know so we could move forward."

I think he remembered the conversation we'd had at the Food Lion and had some questions about the extent of my ambition. "Y'all really trying to get a deal?" he asked.

I shrugged. It was hard still to say the words out loud. "Whatever happens, happens," I said, opting to play it cool. "I'm just making music."

Pharrell took a second to size me up and said, "Well, your shit is sounding good."

I smiled and said, "Yours too, bro."

We shook hands. There was no animosity between us and no looking back.

Pharrell always had something special. If we'd stuck together, I'm sure we would eventually have clashed. It was probably hard for Pharrell to tell me that he didn't want to be in SBI anymore. Another guy might have just stopped showing up and never said anything to avoid the confron-

tation. We went to different schools, so that would have been the easy route. But Pharrell was mature enough to be straight with me and tell me his plans. Technology is great, but I always prefer face-to-face. To me, that personal connection makes a difference.

Every week, I went to physical therapy for my arm, and miracle of miracles, the feeling was beginning to slowly return. It got to the point where I had some use. It wasn't back to my preshooting movement range, but I wasn't concerned at all. My parents separated my senior year of high school, but I still went to church with my mom every Sunday and I always felt like God was watching over me. I missed my father but as he had begun doing long-distance truck driving, he was gone for weeks at a time. In some ways, knowing that he was on the road softened the blow of him not living with us anymore.

It turns out there was one benefit to getting shot—I sued Red Lobster for safety negligence. For a while, I got a nice check from Liberty Mutual every two weeks. I remember the silhouette of the Statue of Liberty on the envelopes that it used to come in. I used some of that insurance money to buy an ASR-10, a basic mixing board. I *still* use that board today.

# 7

# ALL DAY I DREAM ABOUT BEATS

My bedroom was beginning to look like a bona fide studio. Which was fitting because all I did, day and night, was dream about making music. There were wires snaking everywhere and machines, most of them bought secondhand, stacked around my bed. More and more often, as soon as school was out, people would drop by to listen to me make beats and mix tapes for parties. One afternoon, Pharrell swung through.

"Whoa, when did you get this?" he said, running his fingers along my new ASR-10.

"That's my baby," I said with a smile. "We're about to get it on for real. I can start making some serious beats now."

"You've gotta let me check this out," Pharrell said, taking in the sleek console. The ASR-10, purchased courtesy of my Liberty Mutual checks, was the finest piece of recording equipment any of us owned.

"Anytime," I said.

We weren't in a group together anymore, but Pharrell was still my boy and because he knew so much about music, I was always happy when he stopped by. It was fun to have someone else who was just as curious as me exploring the machine's features, all of the special effects and little nuances that might have been lost on another kid. In my little bedroom, we worked on beat matching, scratching and mixing, and we taught each other everything we knew about song structure, melody, harmony and tempo. It was 1988 and we were students of all the best that music had to offer. How did Prince make that crunchy guitar sound on "U Got the Look," and didn't the live drumming by Sheila E. sound so much better than a synthesizer? We loved the funk samples on Eric B. and Rakim's "Follow the Leader." And wasn't it crazy that all the Latin sounds coming out of Miami with Gloria Estefan and the Miami Sound Machine were climbing up the charts?

A few weeks after I got my new equipment, Magoo came back to me about Fayze, the girl group that was trying to put together a demo.

"One of those Fayze girls is going to come by today, after school," he said. "Her name is Missy."

Many kids visited my house my senior year of high school. I was getting serious about music and my mix tapes were beginning to travel outside of the environs of Virginia Beach. I probably met dozens of kids that year with musical ambition: band kids like Pharrell and Chad, wannabe rappers with skills that ranged from "Go home" to "That's awright," girls who thought they were the next

Whitney Houston and boys who thought that a chiseled chest and the ability to string three words together gave them a shot at being the next LL Cool J. The day that I met Melissa "Missy" Elliott from Portsmouth, Virginia, would turn out to be the day that changed the course of my entire life.

She came into my bedroom studio and after the polite hellos and a few compliments about my mix tapes, she asked to hear some of the beats I'd been working on.

For ten minutes, with the exception of an occasional head nod, she was silent. But I could tell she was taking it all in: every instrument, every layer of sound. She was pulling the music apart and putting it back together in her head—the same way that I did.

I'd never even met this girl before but she could match my every move. I played a beat and she started singing, free-styling. The way she sang over my beats, playing with the tempo, throwing harmonies in—I'd never seen anyone do that before. She was just super dope.

Finally she said, "Can you do some stuff for our group? Your beats are different. And that's what I want. If we're gonna get a record deal, we got to stand out."

"You really think you're gonna get a deal?" I asked.

She gave me a little bit of a side eye, a look that I would get to know well. Then she spoke slowly and deliberately, to make sure that I knew she meant business.

"Absolutely," she said. "Nothing's gonna keep me from it."

Missy was different from any of the other girls I'd ever met before. Musical chops—impeccable. Gifted. Focused. Confident. And she made me want to be all of those things

too. I told my mother that night, "That girl was God-sent. She's my sister from another mama."

Missy didn't have the typical look of a pop star. She wasn't super skinny and she was a tomboy. So many people in the industry would dismiss a girl like Missy out of hand. She wasn't the light-skinned girl with wavy hair like Mariah Carey or a bombshell babe like the women in the group of the moment, En Vogue. But when it was her turn to demonstrate what she could do—when I sat on the bed that I'd slept on since I was seven years old and I heard her freestyle rap and sing a cappella—it gave me the shivers. I knew then that Fayze had a chance of getting a deal.

Missy and Magoo came to my house pretty much every day after that. She'd bring the other members of Fayze and they would weave their harmonies over my beats. I was still DJ-ing at parties for the experience and the extra pocket money. I was still working with the remaining members of Surrounded by Idiots on our own music. And I was helping Fayze put together tracks for their demo. I had a lot going on and I was loving every minute of it.

One night after Missy and I had been working on beats until late in the night, we decided to go over to our friend Emmanuel's house.

Missy heard a noise and called us over to the window.

"I don't like the looks of that," she said.

Emmanuel and I didn't either. There were at least twenty guys outside of the house, some with guns in their waistbands. They had lit a fire inside an industrial garbage can and if it wasn't for the fact that I could see for myself how

real it all was, I would have thought it was a scene from a music video like Michael Jackson's "Beat It."

We killed the lights and huddled together behind the blue brocade living room curtains.

"Bring y'all punk asses out here now," one of the guys said, screaming toward Emmanuel's front door.

Missy and I looked at each other. "Wrong place at the wrong time" didn't even begin to cover it. What could they possibly want with us?

"We know you got our shit, niggas!" another guy screamed. He pulled out a gun and waved it toward the window we were peering out of. We all hit the floor, staring at each other.

"What's he talking about?" Emmanuel whispered, looking at us accusingly.

"Don't ask me," I hissed, offended. "It's your house."

"We left the guns right back there," said one guy. "I *know* they were there. And now they're gone, right after these fools go up in that house. They took 'em."

There was a wooded area behind Emmanuel's house. The more they screamed, the clearer the story became. They'd stashed the weapons in the woods. Someone had stolen them. It wasn't us, but there didn't seem to be any way to convince them otherwise.

A random guy rolled down the street on his bicycle. And the guys turned their attention to him.

"Yo, you seen anything?" they asked.

The guy shook his head no and started pedaling faster.

I watched, in disbelief, as the guys waited until the guy

was about thirty feet away and then shot him clear off the bike. Like he was target practice in a carnival game.

I saw the man get up, then limp away, abandoning his bike in the middle of the street. I assumed he would be okay, but I wasn't so sure about us.

"What was that sound?" Missy asked. She was still lying on the floor.

I didn't want to scare her even more by telling her that they'd shot someone.

"They're just shooting in the air," I said, trying to sound reassuring. "Showing off, I guess."

"What are we gonna do?" she asked, terrified.

"We gonna wait it out," I said, sounding a lot more confident than I felt. Even though I lived for music, I still went to church with my mother every Sunday. I remembered something the minister had said about peace not meaning that you would never meet trouble or hard times, but to be in the midst of all of those things and to be calm, faithful, in your heart.

I began to pray right there on the floor of Emmanuel's house. I thought about all the things I'd already survived, from the Robin Hood housing projects to the shooting at the Red Lobster. I knew that God had not brought me so far in the world to let me die on the floor of my friend's house over some mess that we had nothing to do with.

As I was praying, I heard a tirade of gunshots. The guys on the street were done shooting in the air. They were shooting our window in, and we all started screaming. We fireman-crawled our way under the dining room table, hoping the table would give us some protection from the glass

and bullets that were flying all around us. After the window was completely smashed, there was total silence. And we just didn't know. Were they coming in to finish us off? Or were they satisfied with scaring the hell out of us?

We stayed underneath that table for a long time. After about twenty minutes, I crawled over to the window, trying to avoid the shards of broken glass that were scattered everywhere. I peeked outside. They were gone.

We all got up and examined each other for cuts and wounds. Miraculously, none of us were injured. My arm had barely healed and I looked at my right arm, which I had taken to calling my "good arm," like it was a winning lottery ticket. I was okay. I could still make music. That was all that mattered.

We never figured out who those guys were, why they assumed we were the ones who'd stolen their weapons and what compelled them to leave us alone. But that was the way things went down in our part of town. You could die for no reason. You could be spared for no reason. If it made sense, if there were actual law and order, it wouldn't be hood.

The summer after I graduated from high school, a new R & B band called Jodeci came to town. The quartet was made up of two sets of brothers, K-Ci and JoJo Hailey, and Dalvin and Donald DeGrate aka DeVante Swing. K-Ci and Jo-Jo were the lead vocalists; both of them were deep baritones with powerful voices. The group had been signed to Uptown Records by a young Sean "Puffy" Combs. The music that they helped pioneer, New Jack Swing, had taken the country—and the world—by storm. This blend of old-school R & B harmonies over hard-driving hip-hop beats

wasn't what I was doing, but I certainly appreciated both the beats and the way the artists were changing the game. It's funny because I might have tried to jump on the New Jack bandwagon were it not for the fact that the music depended heavily on two pieces of equipment that I didn't yet own: the SP-1200 and the TR-808. While Teddy Riley was the godfather of New Jack Swing, a whole roster of artists were developing the sound and making it their own: not just Jodeci, but also Heavy D and the Boyz, Tony! Toni! Toné!, Full Force, Al B. Sure! and LeVert.

Like me, the guys from Jodeci had grown up in the church. Like me, they loved the way artists like Prince were changing the black music game. In fact, one of the members of Jodeci, DeVante, had driven from Charlotte to Minneapolis to audition for Prince's band when he was sixteen years old. The Purple One turned him down.

That year, Jodeci had hit it big with a string of hits, including "Stay" and "Forever My Lady." Their debut album was three times platinum. Which is why, as you can imagine, I was surprised when Missy announced that she was going to track them down after their concert and sing for them.

"What makes you think you can do that?" I asked, incredulous.

Missy just gave me her unflappable grin. "Because it's going to happen, that's why. Me and my girls are going to sing for them and then I'll give them our demo tape with all of your beats. When we get signed, I'll make sure you get a part of the deal."

I took a deep breath. *It must be nice*, I remember thinking,

*to wake up every morning so sure that things are going to work out the way you want them to.* But what I said was, "Good luck. I believe in you." The last part wasn't entirely true, but I was learning not to underestimate Missy—her talent or her willpower.

# 8

# ON LIKE DONKEY KONG

The next time I saw Missy, she was in my bedroom/studio jumping up and down. "We did it, Tim!" she screamed. "We sang for Jodeci and DeVante liked us!"

"DeVante Swing" was the stage name of Donald DeGrate. He was the main songwriter and producer of the group. In addition to his work with Jodeci, he had a musical collective called Da Bassment. He'd just begun to sign and produce his own artists.

I could hardly believe it as Missy told me about how she and the members of Fayze had snuck backstage, right before the show ended. They wandered around trying to figure out the best place to position themselves, then decided to wait near the exit closest to the tour bus. After the show finished, the band members hung out backstage for over an hour. There was nobody by the exit where Missy and her friends were waiting. They began to wonder if the band had gone out a different way, or maybe taken cars to

go out and eat. Finally, they saw DeVante, and Missy asked, "Can we sing something for you, really quick?"

I almost jumped up and down myself when she said the song they sang was "First Move," a song *I'd* produced. DeVante told the girls he liked their sound. Then he took their tape and promised he'd be in touch.

Missy was beaming. "I told you, Tim. It's about to be on. You didn't believe me, but I'm not playing. I want this. And I'm willing to work hard. Are you?"

I assured her I was. Slowly but surely, I was gaining the courage to put a music career front and center in my dreams. My parents weren't happy about the fact that I wasn't going to college. My part-time DJ career brought in just enough money to keep gas in my car and equipment in my make-shift studio. Every night when he got home from work, my father grumbled about my lack of "gainful employment." I couldn't explain because I couldn't quite see it yet, how I was going to make a living off of the beats I was creating. But as I watched Missy push her way ahead, I began to think that maybe what I was doing for love might also bring in some real money.

Things started to move fast after that. DeVante got in touch with Missy within days, and the first thing he did was rename her group. Fayze became Sista, and a contract appeared, making Missy and Sista the newest members of DeVante's Da Bassment. It was all shaking out the way Missy said it would. She also kept her promise about bringing me along for the ride. She let DeVante know that I was part of the Sista package, the bro who made the beats.

One night, just a few weeks after the Jodeci concert,

Missy took me to a nearby recording studio to meet the man himself. DeVante had the whole star thing down—so much so that it was a little off-putting. He was riding this huge wave of success and everything about his appearance was over the top. He had a Prince-style curly-hair thing going on. He was wearing shades when I met him, even though it was night and we were indoors. I would later learn that DeVante always wore sunglasses—day or night, inside or out. I thought it was a little much. Yeah, Jodeci were big. But they weren't Prince big. They weren't Michael Jackson big. However, the way DeVante was acting, it was like I'd been granted an audience with musical royalty.

I was determined to keep it real.

"What's up?" I said, reaching out to shake his hand.

He looked me up and down and asked, "What's your name again?"

"Tim."

"Tim," he said, nodding his head. "Like Timberland boots."

Timberlands were the outdoor hiking and construction boots that had become popular in hoods from coast to coast. It was kind of ironic that this footwear, designed to handle all kinds of mountainous terrain, became popular among hip-hop kids who did most of their climbing in their dreams. But while nobody outside of Virginia Beach knew DJ Timmy Tim, everybody knew Timberlands. So the nickname stuck.

DeVante said, "I like the beats you've been doing for Sista." He spoke in a soft voice, much like the men who were clearly his idols, Michael Jackson and Prince. "We're

planning big things for them. And Missy said you're the one to handle this project."

"I can do it," I said, trying to channel some of Missy's unshakable confidence. "In fact, I'm the only one who can."

This seemed to get his attention and he gave a little smile. "I'll be overseeing the project. But we're still on tour and recording our next album, so you run with this and we'll see what you come up with."

It was really happening. Missy and Sista had a record deal and I was their in-house producer. Missy got a small advance and I got enough money that I could make music all day and cover the few bills that were mine, living in my parents' house. For the first time ever, I kept my gas tank full.

A few weeks later, Missy came over, excited and just about ready to jump out of her skin.

"Are you ready to get out of Virginia Beach?" she asked.

"What do you mean?"

"Just what I said! Are you ready to get out of here?"

I was pretty comfy with my setup at home. "Depends on where I'm going."

"Jersey," Missy said, a big Cheshire cat grin on her face.

"New Jersey?"

"No, man. Old Jersey. New Jersey. What else could I possibly mean?" Missy said. "DeVante wants us to move up there to this house he's renting with the rest of the Da Bassment crew. He wants us to work on the Jodeci stuff and his own stuff. It's just what we need, the chance to be side by side with those guys instead of us working on music, then waiting for them to come down here and check it out. This is what we've been waiting for, Tim!"

I had to admit it was exciting. Get out of the dirty South. Be right across the river from New York City. Spend my days and nights living in a house full of musicians. Maybe I hadn't made it to college, but it looked like I was still going away to school.

**DEVANTE LIVED IN** Teaneck, New Jersey, and he moved me, Missy and the members of Sista into an apartment in nearby Hackensack. We were so starstruck, it was like somebody had plopped us right in the middle of Hollywood Boulevard. We were still teenagers and we were making it: we had our own place and a record deal with one of the biggest artists of the moment. Neither Missy or I had been out of Virginia much and as we drove up the Garden State Parkway, Missy grabbed my shoulder and said, "We'll be all right . . . right?" It was both a question and an answer.

We moved into this two-bedroom apartment. Me and three girls and a ferret. Don't ask me why but Radia, the youngest girl in the group, had been allowed to bring her pet ferret to the new apartment. I set up all of my equipment in one bedroom, where I worked and slept, just as I had at home. All the girls shared the other bedroom. It was super cramped. But we felt lucky to be there. It never dawned on us to complain or ask for larger living quarters. We were so happy to be down that DeVante could have given us a studio apartment with no electricity and we would have said okay. But it's a lesson I wish I could go back and teach my younger self, and it's what I tell new artists today: If someone in the music industry wants to work with you, they're not doing

you a favor. You're at the party because you've got something—a gift that they can use. Be humble. Know you've got to pay your dues. But don't sell yourself short. Just because you're unproven doesn't mean you have to bunk with a ferret.

I was especially grateful to Missy because she'd insisted that I come along to produce for Sista. Once the group was moving to New Jersey, DeVante had planned to produce all of the Sista tracks himself with the help of singer Al B. Sure!, who was making a lot of noise in R & B at the time. But Missy had insisted on working with me.

Over the next few months, we worked on more than twenty songs together. Our little Hackensack apartment was a lab, and we poured it all into the music: all of the love, all of the heartbreak, all of the sadness and all of the joy that we'd experienced thus far. I felt like my life finally made perfect sense. All of those sounds I'd been storing in my head were useful, a library of pitches and tones that I could draw from to add color and depth to every note we were writing: from my baby brother's gurgles to the sound of my mother stirring the pot when she cooked our Sunday supper to the Saturday afternoon tracks that made me and my daddy dance.

When the record was done and we turned it in to DeVante, we were nervous but excited. It definitely wasn't a New Jack—or New Jill—Swing album.

"What if people don't get it?" I'd ask Missy.

"They will," Missy said. "When people hear it, they'll get it. All we have to worry about is actually getting the record out."

Weeks turned into months and we couldn't get in touch

with DeVante. We crowded around the TV in the apartment and watched Jodeci perform on *Soul Train* and then we heard that they had left for a tour with Mary J. Blige. But the phone never rang in Hackensack, and we couldn't even get the assistants at the label to pick up when we called.

One night, Missy and I sat around the kitchen table, serving ourselves from a big pot of ramen noodles. What had seemed like a decent advance had winnowed down over the months and funds were low.

"What do you think is going on?" Missy asked.

I shrugged. "I don't know. Maybe things work slowly like this in the industry."

Missy raised an eyebrow. "Not this damn slow. Somebody could tell us *something*."

I asked the question that we hadn't dared voice out loud yet. "Do you think the group is getting dropped?"

She recoiled as if the very words stung. "It can't be. But . . . something's not right."

"What are we going to do if that's the case?"

Missy, who was always the true believer, gathered up her optimism once again. She said, "Let's not play worst-case scenario. We've worked too hard. It can't end like this."

"But, Missy . . ." I thought maybe, this time, she needed me to be the practical one.

"Let's just wait," Missy said. "I'm not going to freak out yet. We made a good, solid album. Your beats are on point. The lyrics and melodies are solid. We've done everything we've been asked to do and more. This will work out. Let's just wait."

# 9

# DIARY OF A MAD MENTOR

It was just like that Marvin Gaye song. When DeVante lost his producing deal, we heard it through the grapevine. When Missy came to talk to me about it, I sat in the bedroom, unable to look her in the eye. She'd worked so hard, and more than any of us, she believed that this was going to be the album that would take us to the top of the charts. Now Sista was being put on hold indefinitely, maybe permanently, because without a producing deal, there wasn't much DeVante could do for the group.

"So you heard about DeVante?" she asked, fiddling with a piece of equipment.

"Yeah," I said. "Word is he's shopping other groups to some labels."

"But not us?" she asked.

"I don't think so," I said.

Missy was devastated. The fearless girl who'd stood by the concert hall door to sing her heart out and been rewarded with

a record deal was now right back where she'd started. But maybe a little worse off, because now she'd had a glimpse of the Emerald City and she wasn't going to stop until she got all the way to Oz.

"Now what?" Missy asked. She was crying, and I stood up to put my arms around her. "I'm not going back to Virginia."

"Me neither," I promised her.

She pulled away from me and I could see that she was talking herself off of the heartbreak ledge. She was determined to turn the situation around. "We have to keep recording, Tim. We have to keep making songs. For ourselves, Tim. I don't care if the only people who hear our music are me and you. We just have to keep doing what we're meant to be doing. I'm meant to write songs and sing. I know that. You have a gift for making music. I know that too."

Missy's words comforted me, and I thought about two of my favorite Psalms verses, Psalm 118, verses 8 and 9: *It is better to trust in the Lord than to put confidence in man. It is better to trust in the Lord than to put confidence in princes.* DeVante may have seemed like a prince of the music industry, but whether prince or man, he wasn't the one to have faith in. If Sista wasn't going to work out, then the Lord must have had a different plan.

A few days later, DeVante came to us with another plan.

"Look, I can't sell Sista to another label. That's done. En Vogue is still holding on strong, there's a new group coming out of Atlanta called TLC, not to mention Whitney, Mariah and Mary J. Blige. That space is crowded," he said. "I want to see Tim, Magoo and your boy Larry Lyons as a group. Missy will write and produce. What do you think?"

I wish I could say that what I thought was, *Fool me once, shame on you. Fool me twice, shame on me.* But I was eighteen years old, and he was one of the biggest artists on the charts. Any shot seemed like a shot worth taking, so Missy and I said yes.

Now it was my turn to sign on the dotted line, and I signed on to DeVante's Swing Mob label, which had a brand-new deal with Def Jam. Magoo and Larry moved to Hackensack. The other girls and the ferret moved out and we all started working out of my bedroom studio.

A few more months passed. We wrote another twenty songs. And then DeVante started disappearing. It's torture when you spend your nights and most of your days locked in a dark recording booth, making music that you fear no one will ever hear. It was different in Virginia, when we were just a bunch of high school kids calling ourselves Surrounded by Idiots. Back then, our expectations were low—all we ever wanted was for the local DJ to do us a solid and spin one of our tracks. But this was different. DeVante owned the publishing rights to everything we created. It was entirely up to him to give us credit for the tracks, and if he wanted, he could walk away and sell the songs to other artists without giving us a dime or putting our names down as songwriters. If this deal was shelved, the way Sista had been, then we'd walk away with nothing, not even our own tunes.

Finally Larry said he was out. "I can't deal with this any-more."

"What are you going to do?" I asked.

"I'm going back to Virginia," he said. "We call this dude and he never gets back to us. We're using up all our time

and all of our money making these tracks, and for what? It's ridiculous. I'm going to go home and get a job."

I couldn't blame him. We were short one member, but we continued to work on the music, hoping that DeVante would show up and give us some direction. But Jodeci was in the midst of recording their sophomore album, *Diary of a Mad Band*.

Our group gradually fizzled out, but DeVante threw us a bone—and by any standard, it was a pretty big one. He asked me to produce "In the Meanwhile," a hard-driving midtempo track that had a six-second sample from James Brown's seminal album *The Payback*. The year was 1993 and I was twenty-one years old. So much was screwed up about my situation but I kept telling myself, "You're making music. You're making music. All that matters is you're making music." Missy contributed vocals to that track as well as to "Won't Waste You" and "Sweaty." The songs weren't released to radio and they weren't hits, but it didn't matter. Missy and I could go into any record store and see our names in the credits on an album for one of the biggest R & B groups in the world. We were right there.

Not too long after the release of *Diary of a Mad Band*, DeVante did a side project with Tupac. The song was called "No More Pain" and the first time I heard it on the radio, my heart started thumping real fast. I knew that beat.

"Did you do this record?" Missy asked me as we both listened to the song in my car.

"No," I said, my mind racing. "DeVante did."

"But it sounds like one of *your* beats," Missy said. "Every

lick, every sample, everything about it sounds like you. It's even got that *womp womp* sound you use. And I hear when you were working with that Wu-Tang sample. What's going on?"

"I didn't say anything to him," I said, trying to keep my voice low and steady.

"Are you going to speak up?" Missy asked.

"No, but now I know who I'm working with," I said. "And believe me, I'm not forgetting this one. Let's see what he can do for us and if something doesn't pop soon, I'm moving on."

If we had any sense, we would've packed our bags and headed back to Virginia Beach. I was never given any credit for that song. But Missy and I were still dead set on making our dreams come true. And DeVante seemed like our best shot. What can I say? Sometimes when you're young and ambitious and your dream is so close you can taste it . . . sense ain't got nothing to do with it.

**SOON AFTER, DEVANTE** came over to our Hackensack apartment to listen to some tracks.

"I like what you're doing," he said softly. "I like your sound.

"I'm thinking it would be easier if you came out and stayed in my house in Teaneck, instead of me driving back and forth," DeVante said.

"And Missy will stay here in Hackensack?" I said.

That didn't feel right to me.

"It'll be cool," DeVante insisted. "A lot more of Da Bass-

ment crew is headquartered over there and we can get a lot more done. You've got a little bit of equipment here but you need to be in a real studio to get your best work done."

I agreed with him there. I was working with the small amount of equipment that DeVante had bought us when we came up from Virginia. I'd used it to make decent tracks for Sista and for DeVante's other group, Playa, but it wasn't nearly as good as what I needed.

"All right, let's do it," I said.

I packed up what little I had and went over to Teaneck. I was surprised at how ordinary the house was. In my head, I'd assumed that DeVante would have some sort of palatial spread. But it was just a sprawling suburban two-story.

When I stepped inside, the first person I met was K-Ci, the lead singer of Jodeci.

"What up, man, welcome to Da Bassment," he said, shaking my hand. DeVante was the group's leader but K-Ci was the band's front man. He had a voice that reminded me of Al Green—smooth and deceptively easy, but with a little extra rasp to it. He was a bit of a throwback, a real crooner. In real life, he came across as aggressive and a little jumpy. But he seemed genuinely excited to have me there and producing music.

I also met Ginuwine, a young singer from the DC area who had recently been pulled into the fold.

"Hope you're ready to work," Ginuwine said. "We live in the studio 'round here."

He then took me down to Da Bassment, the studio where we'd be spending most of our time. Everything I could have wanted musically was there, including an ASR-10 and a full

mixing board. At the time, the chance to work with professional musicians, on the finest equipment money could buy, seemed like my every dream come true.

The sleeping quarters were nowhere near as nice. There were guys piled three to a bedroom. Luggage and clothes were splayed everywhere. No wonder DeVante hadn't thought twice about me and Sista sharing that tiny two-bedroom in Hackensack; his own house had the same tiny dorm-room feel.

I spent twenty-four hours a day in that studio in Teaneck. As soon as I woke up, I headed downstairs and listened in on the work they were doing for *Diary of a Mad Band*. Missy and I had worked on a few secondary tracks. But at Da Bassment, I got to see how they worked on the big radio singles, the songs destined to burn up the charts. There was a certain grittiness to *Forever My Lady* that the group purposefully moved away from on the second album. The ballads I saw them working on, songs like "Cry for You" and "What About Us," drew as much on the music of Bobby Womack and Stevie Wonder as they did on the music of Teddy Riley and Keith Sweat.

Whenever I do a ballad, it's my inclination to be a little less earnest. I like to bring together disparate elements, sounds and samples that may not scream "love song" but capture what I feel in my own life and what I'm hearing in the voice of my artist. But in the early nineties, when I was still so young that I couldn't even legally buy a drink, I had to sit back and watch and learn. And I did learn a lot from watching DeVante put bars together, write lyrics and structure the song from build to bridge and back again.

That front-row seat to a multiplatinum-selling producer was invaluable, even if the music wasn't at all my style.

I'll always give credit to DeVante for what I learned. The problem was that we were not consistently compensated. We were all there, we quickly discovered, to be of service. We survived on the band's leftovers, literally. Almost every afternoon, the guys in the band ordered a pizza, and after they'd returned to the studio, me and all the other guys just dove in to get whatever was left: bits of crust, discarded pieces of pepperoni. Anything. We were that hungry.

For months on end, we did anything DeVante asked us to do. We fetched food (that wasn't always for us). We ran errands for the band and the girlfriends of the band. We cleaned toilets and washed dishes and ate room-temperature Chinese food from the plates they left behind. But we didn't leave. We didn't put up a fight. We were *this* close to our big break in the record industry. And we were that hungry.

Whenever DeVante and the other members of Jodeci were out, we would run for the studio. It was all about whatever was going to get us out of Da Bassment (literally) and into the real world.

"Get up, Tim! Studio's empty," Missy said, knocking on the door of the tiny room where I slept on a mattress on the floor, with two other guys in sleeping bags next to me.

"Let's get in there and knock something out," I said, smiling. Nothing made me happier than studio time, and Missy's energy was, even back then, infectious.

Missy smiled. "I'll race you. I bet I can finish lyrics and a melody before you can finish a beat."

Missy and I always raced to see who could come up with

the most songs in a single session. Sometimes we could make a complete song—beat, hook and lyrics—in an hour. We stockpiled dozens and dozens of songs this way, playing them to whoever would listen for feedback and suggestions.

We were in the studio, working on songs, when my mother called.

"Tim, I hate to ask you this," she said. "But is there any way you can help me out? I've fallen behind in our mortgage payments and I'm in danger of losing the house."

Ever since my parents' divorce, I'd become the man of the house. The sound of my mother's crying was imprinted on my brain, and for me it was more excruciating than any other sound I could imagine. I was little more than a kid myself, but I was happy to step in and be there when my mother needed me. When I DJ-ed, I always put aside a little money to help my mom out. When Missy got her deal and I got a little cut, a few hundred dollars, I gave my mom some of that too. But it had been months since I'd sent even a nickel back home. It hadn't occurred to me how much those little checks I gave my mother had helped her out. Not only did I not have the cash to save our home, but just the day before, I'd been so hungry that I'd been on my hands and knees, searching the bottom of my car for spare change so that I could scrape together a dollar for a Happy Meal at McDonald's.

"I know we are going to get put on soon, Mom," I said. "I can't help now, but I'm going to pray."

I could hear the smile in my mother's voice. "You still got your Bible with you, Tim?"

"You know I do," I said.

"Then you make sure you read Proverbs Three tonight."

"I don't need the book to tell you what that says," I assured her. *"Trust in the Lord with all your heart and lean not on your understanding. In all your ways acknowledge him and he will make your path straight."*

"I love you, son," my mother said.

"I love you, Mama."

When I hung up the phone, I was embarrassed, and Missy could tell.

"Just hold on," Missy said. "DeVante's distracted with the new album, but we'll get our turn."

"We're not getting paid," I said. *"Anything."*

Missy said, "I know. But we do get free studio time. That means something. What did we come here to do?"

"Make music," I said.

"And what are we doing?"

"Making music . . . that no one is hearing."

Missy grinned. "That'll change. Have faith, tiny Tim. Ebenezer Swing will see the error of his ways and do right by us."

I had already realized that DeVante could be really nasty. When he sent us out to run an errand, he made a point of counting the change down to the penny. If you tried to pocket even a quarter, it was at your peril. He smiled widely when we asked for a bar of soap or a tube of toothpaste. "Enough," he said, as if he were the ruler of a kingdom and we were bothersome serfs. "I can smell you from here. I'll give you a bar of soap."

Then DeVante decided he wanted to be managed by Suge Knight. At the time, Suge was the most feared man in hip-

hop—if not the entire music industry. The story was that he'd risen to fame when he (allegedly) used force to get Dr. Dre out of a deal with Eazy-E and Ruthless Records. Dre and Suge started Death Row Records together, and they had achieved amazing commercial and critical success with Dr. Dre's debut solo album, *The Chronic*, which went triple platinum. The following year, they put out another instant classic: Snoop Dogg's debut, *Doggystyle*, which went quadruple platinum. And from that point on, Death Row was the label to beat.

But Suge had a reputation for being (allegedly) violent and reckless when it came to handling conflicts in the industry. There was a beef with Puff Daddy and the Bad Boy record label. There were stories about his dangling rappers out of windows to get what he wanted. Suge bailed Tupac Shakur out of jail and signed him to Death Row Records. This led to some great music, including Tupac and Dre's hit song "California Love." The song not only went double platinum, but it showcased so much of the innovative producing that made Dr. Dre the artist he is to this day. "California Love" features a sample from British blues singer Joe Cocker. The piano hook and horn stab from Cocker's track "Woman to Woman" are the melodic bass line to what would become Tupac's biggest mainstream hit. The Cocker sample is a genius touch, but Dre took it to the next level when he brought in funk legend Roger Troutman to perform the chorus, "California knows how to party," using his signature talk box. Troutman also added another talk-box-modulated "shake it, shake it, baby" that was taken from his group Zapp and their 1982 single "Dance Floor."

I admired the music, but I was still surprised that DeVante would align himself with Death Row and its founder. On the few occasions when Suge came by the studio, I took care to stay out of his way. I'd been shot. I'd seen friends stabbed and shot. I knew what Suge was about and I wanted no part of it. But it became clear that DeVante wanted to add some of that gangsta lean to the legend of himself that he was creating in his mind.

Increasingly, assistants smacked up a few of the producers in Da Bassment crew—just to make sure that we all understood there was a chain of command and any insubordination would be punished. I'm not naming names because some of the producers went on to become pretty well-known. But one by one, we all got hit—and for no good reason. One guy was slapped so hard that we had to rush him to the emergency room with a busted eardrum.

The longer we stayed, the more twisted our situation became. We would go for days without eating. We would be woken up in the middle of the night to run crazy errands. We were knocked around, kicked around, and beat down. It was like we were in this ghetto fraternity and DeVante's crew was the big brother of our line. I don't know why I stayed. But I think about all the hazing that goes on with Greek organizations on college campuses, and I remember the feeling of wanting to belong and how every day, you keep thinking, *There's light at the end of this tunnel and when I get there, it will have all been worth it.*

The uncertainty was the trickiest part. None of us knew where we stood in our musical careers. I was supposed to be signed as part of my own group with Magoo (since Larry

had returned home to Virginia). But as was the case with DeVante's previous promises, that never happened. The deal just evaporated without a definitive word or explanation from anyone.

In addition to working out of the house, we spent a lot of time at a recording studio in Upstate New York. The studio had a twelve-track Akai recorder and a whole suite of world-class equipment. There was also a lot of weird shit going on in that studio. In one room of the building, one of the producers had pornographic movies on a loop all day long. He spent long hours in there, doing drugs and watching porn, while women came in and out of the room. It was quite the revelation for a country boy like me. And I'm not one to judge, but the porn and the drugs made me uncomfortable, mostly because I'd been around enough to know that the more erratic variables you add to the mix, the more combustible a situation is likely to become.

We were sitting in the kitchen of the studio when one of DeVante's lackeys came at me.

"You stole my money from off of this table?" His eyes were bleary and I thought that he was probably high.

I tried to keep my voice calm and even. "I didn't touch anything that belonged to you."

"You lying, fool!" he roared. "I know you took my money."

He broke a bottle against the wall, then, holding the bottle by the neck, he came toward me. The jagged edges of the broken bottle were pointed at me and I took a step back.

"I didn't touch anything that belongs to you. I'm not a thief," I said, trying not to raise my voice.

He stood there staring at me. I held my ground, not

because I was brave but because I'd been in enough street fights to know that if there was a long enough pause, there was an opportunity to end it before any blood was shed.

"I respect you, man," I said. "And I respect *myself.* I would never steal from you."

He seemed to hear me, because he lowered the hand that had been brandishing the bottle.

"Act like you know," he said. "And let all those other punks know that if they try to steal from me, they are going to get served."

"I will."

"You hear me?" he said, walking away.

I felt slightly dizzy, like I'd been holding my breath for far too long. "I hear you," I said.

It wasn't merely the thug antics that made me realize how badly I needed an exit strategy. The recording studio was decorated with skulls everywhere and every time we visited, I felt like the place was haunted. One night, I set up a tiny sleeping area in the basement studio so I could grab a few winks before the next recording session. I woke up with the feeling that there was something heavy on my chest, something that wasn't allowing me to move. I was wide awake but I felt entombed in my own body. I couldn't open my eyes, though I tried. I couldn't move my lips or open my mouth, though I was trying to scream. I couldn't move my arms or my legs. I felt held down by this sinister energy and all I could do was pray, pray that just like those gangsters who thought we'd stolen their guns at my friend Emmanuel's house, the spirit would be content with scaring me and eventually go away. I lay there, silently repeating

one of my favorite Bible verses. First Corinthians, chapter 16, verse 13: *Be on your guard, stand firm in the faith, be men of courage, be strong.* When I could finally move, when I felt free and in my body again and the heaviness that had been holding me down had moved on, I was cold and clammy. I was afraid, but I also felt that I'd been warned. What had me so uncomfortable wasn't just the drugs and the porn. It was something deeper, something bigger. There was true evil in that building.

# 10

# ALL FALLS DOWN

Nineteen ninety-five was for me, and many others, a year of death and devastating shake-ups. The Unabomber was terrorizing the country with letter bombs. Timothy McVeigh had blown up a federal building in Oklahoma City, killing 168 people and injuring over 600. The O. J. Simpson trial dominated the news and spurred the media to once again aim to classify us as a nation of blacks (who supposedly all thought O. J. was innocent) and whites (who supposedly all thought he was guilty).

Musically, it was also an interesting time. TLC was at the top of the charts with "Creep," a playful pop anthem that was produced by Dallas Austin. Brandy had just released her self-titled debut and the single "Baby" was charting high. In the world of hip-hop and R & B, Puff's Bad Boy label was running the show with artists like Faith Evans, Total, and of course, the Notorious BIG.

I listened carefully to everything on the radio. But I didn't

dilute my sound. I knew I wanted to do something different, eclectic, and that one day my music would be heard.

I was in the studio with Static, one of the members of the singing group Playa, who lived with us in the Teaneck house.

"I like this beat," I told Static as he played me something he was working on. "But it needs more. Give me a double-time snare on top of it."

I nodded my head when he added the snare. But I knew the beat needed something unconventional. I closed my eyes and began rifling through my catalog of sounds. Then I went through my samples and found what sounded like a futuristic robot saying the word *yeah* over and over in different tones. I added that *yeah,* then combined it with the sound of a slide whistle. Slide whistles are often referred to as toy whistles, and they instantly gave the track a playful vibe. You can hear a slide whistle in Deee-Lite's 1990 hit "Groove Is in the Heart," and its unusual sound has made it a popular audio element in cartoons from *SpongeBob* to *The Simpsons.*

I had also started to develop what I called a warp style of making beats. If you leave a record out in the sun, it will warp. You might be able to still play it but it's going to have a strange, distorted sound. I loved that sound and I started making beats with that vibe. I was thinking, *Warp it a little,* when I added belching synthesizers to the beat I was working on for Static.

When I finished the beat, Static started writing to it, thinking it would make a good track for the Playa album.

"This track is a monster," he said. "But the lyrics I

got aren't making it. I need more time to make it work."

We started working on it every day, playing the track over and over. It was an unusual beat and it was easier to get the writing wrong than to get it right.

One afternoon, Ginuwine came into the studio while I was tinkering with the beat and Static was trying to write to it.

"I need that beat," Ginuwine said. He was more amped than I'd ever seen. He was usually a laid-back cat.

"Nah, that's for Playa," I said. Although I will say that at that point, saying a beat was for any particular member or group in Da Bassment was like shopping for real estate with Monopoly money. It was all make-believe until DeVante started to show and prove.

"No, you don't understand," Ginuwine said, his eyes widening. "I need *that* beat. That joint is hot to death."

Static and Ginuwine started writing together, reimagining the song as a sexy R & B joint. The hook came first: *If you're horny / Let's do it / Ride it / My pony.*

The song was a departure from the typical R & B of the day. The beat was hip-hop hard and the lyrics were sexually direct. There were the little oddball elements that I loved, like the warped synthesizers and the slide whistle. Ginuwine's voice was strong and clear, perfect for the beat. Altogether, the song, called "Pony," was hyperkinetic. We were so proud of ourselves for what we created, but as the days turned into weeks and DeVante wouldn't even listen to our track, the joy deflated. We shelved it, like we had so many songs, for our "future album."

Although I could hardly believe it, it had been three

whole years since I had moved to New Jersey to write beats for Missy and Sista. Sista's deal had gone away. Then I was supposed to be in a group with Larry and Magoo. That went away too. I moved into the Teaneck house to be part of Da Bassment and even though I'd gotten a front-row seat for the making of popular R & B tracks, I had no money. Me and the guys from the crew were still scrounging for food, eating leftovers from DeVante and his boys. I'd made tons of music but hadn't reaped the benefit of it. I was stuck, but I was afraid of leaving just before everything popped off. I didn't want to be the fifth Beatle.

DeVante and his boys always had a string of girls in the studio. I barely bothered to remember their names. But there was one girl who was different: Dana. There was something soft, innocent and sweet about her. I'd pass her in the studio and think, *What are you doing with a guy like DeVante?* It goes without saying that living in the basement, walking around in the same clothes day after day, surviving on fifty-cent packs of ramen noodles—and sometimes only one of those a day—I wasn't doing much dating. I told myself it didn't matter. I was married to the music. Romantic love would come later.

It was easy for the days to run into each other when each one held the same mind-numbing monotony. I would wake up, pray, go straight to the studio, work on my music, try to find something to eat, go back to the music, run errands for DeVante if he was in town, then go to sleep. I did that on repeat for months without end. Then my mother lost her house and I had to take a hard look at how much of what I

was doing was training for the big leagues and how much of it was just hoping.

When my mother called, I could tell she was upset, although she was trying hard to keep it together.

"What's wrong, Mom?" I asked.

"We lost the house, baby," she said, sniffling. "It's been foreclosed on."

My heart sank. I was twenty-three years old. Old enough to be more of a help than I was. Maybe this was my wake-up call to finally leave DeVante and his basement of hollow promises.

"I'm coming home, Mom," I said. "I'll get a job and find us a place to live. I will fix this."

But my mother wasn't having it. "You will do no such thing," she said insistently. "You're going to stay exactly where you are. I know the gifts that God has given you, just as surely as I know that God will provide for me. Your brother and I will stay with your grandmother until I can get myself sorted out."

I remembered how much of a refuge my grandmother's house had always been throughout my childhood. But that didn't mean I wanted my mother living there with no place to call her own.

"Mama, how am I supposed to stay here, making no money, while you're out there, homeless?"

"You just do it, Tim!" my mother said. "You've come this far by faith. Don't walk away now. I don't know much about the music business but I know you don't get opportunities like the one you have all the time. If you come home, you'll

be dining on regret every minute of every day. I don't want to see you suffering. Not in my name."

I could feel the tears forming in my eyes and I widened them with the hope that I could keep them at bay. I'd dragged one of the phones with a long cord to a little corner of the basement. But half a dozen dudes were just a few feet away.

"I just want you to be okay, Mama."

"Don't worry about me," she said. "I have God on my side and I will *always* be okay. You work on your music."

"But it's not going that well," I said. "We haven't placed any songs and nothing is going on with the group. They're not paying us. We're not eating. It's a mess."

"Are you losing faith, Tim?" my mother asked. "Is that what I'm hearing?"

"No, ma'am," I said.

"I didn't think so," she said. "Now, buckle down and get back to work. We'll be fine."

When we started talking, I thought it was my job to bolster her, to lift her spirits. But by the end, she was the one who was holding me up, urging me to keep going. My mother may have been just eighteen years old when she had me, but she came at mothering with all the fierce determination of a woman twice that age. She loved hard and God was her wingman. It's because of her that I am who I am today.

On the day that my mother called to tell me her house had been foreclosed on, I'd gotten up, prayed, nibbled on a hard roll that had come with the Italian takeout that DeVante's boys had ordered the night before and come down to the studio to make beats. The red gas light was on in my car and

I had $1.25 in my pocket. It was a good thing there were no mirrors in that basement, because if I had to take a good hard look at myself, I wouldn't have liked what I saw.

I told Static and Ginuwine that I had an emergency to deal with, then I drove straight over to the apartment in Hackensack, where Missy was still living with the girls from Sista. I told her what had happened to my mother's house and she asked if I wanted to move back home to help out.

"I do, but my mother told me not to," I explained.

Missy shook her head. "Your mother is a beautiful person," she said. "She believes in us even when we're not believing in ourselves. We'll make it, Tim." Then she took my hand and said, "Trust. You're going to buy your mother an amazing house one day and we'll look back at this day and laugh."

**THAT WINTER, THE** Teaneck area was hit with a number of record-setting snowstorms. I'm from Virginia Beach and I wasn't used to that level of snow, but I did my best to deal with it. One thing I hated to do was drive in the snow. Way too dangerous. I'd bundle up and walk to the store when the weather got bad. That year, I was driving a silver two-door Mazda RX-7. DeVante had bought it for me instead of giving me royalties for the records I was working on. If I'd used the sense God gave me, I would have asked for the money he owed me instead. But I was young and having a nice ride still meant a lot to me.

One night after a particularly brutal storm, DeVante said to me, "Yo. Take Dana to the store for me."

Dana was his girl of the moment and whenever he needed

to deal with any of his women—take them to the train, to the store, or whatever—he usually asked one of us.

"She's hungry," he said. "Take her to get something to eat."

"Fine," I said, mainly because I figured I could get something to eat as well. It had gotten to the point where the other producers and I would regularly boost ramen noodles and loaves of bread from the corner store just so we could have some food. "Come on, Dana," I said. "Let's go."

I let Dana into the passenger side of the car and we both strapped on our seat belts. I eased the Mazda out of the driveway and started driving in the direction of a nearby takeout place.

The next thing I remember is the car spinning in circles in the middle of the street. I was trying frantically to pump the brakes and steer straight but I couldn't get control of the car. I'll never forget how Dana screamed and screamed as the car doughnutted off the street and straight into a tree.

I don't remember the feeling of the impact, but what I remember is the feeling of being a very small boy all over again. I was sitting with my Fisher-Price record player and I was mesmerized, as I was back then, by how the minute you set the needle down on the grooved record, the music would start. I walked away from the Fisher-Price and in the next room, there was my dad proudly showing me my first set of turntables, which he'd bought for me because he knew I wanted them so badly. I was in Red Lobster, holding my arm after I was shot. I was riding beach cruisers in Virginia. I was breaking up fights between Caleb and Joey. Then I was back in my bedroom, in the house my mother lost in the

foreclosure. I was making beats after school and in walked Melissa "Missy" Elliott. She was introducing herself—"Hi, I'm Missy"—and shaking my hand like we'd never met before. I knew then that something was very wrong. It wasn't the white-light experience, but I think I knew then that my life was flashing before me and I was in another place.

I awoke with a start and Dana was unconscious in the seat next to me. I knew I had to get help, and fast. The car was so twisted against the tree that I didn't think I'd be able to get the door open. I could only see out of one eye. There was blood pouring out of the other one. I pulled the handle on the driver's-side door and miraculously, it swung open. That was God at work right there and no one will ever be able to tell me otherwise.

I stepped out into the snow and I could see DeVante's house in the distance. I walked toward it, each step an effort. The streets were covered with snow and there was no one walking but me. I collapsed in the doorway of DeVante's house. Seconds later, Missy opened the door and started screaming for everyone to come help me.

"Dana," I whispered. "She's in the car. Call an ambulance."

After I said those words, I blacked out. I woke up in the hospital.

# 11

# THIS IS NOT A TEST

**W**hen I woke up, I was wearing an eye patch and the pain in my head was excruciating. Missy was there, waiting for me. I had only one question for her.

"Where's Dana?" I asked. "Is she okay? What room is she in?"

Missy looked at me carefully.

"She died this morning, Tim," she said in a soft voice.

I couldn't believe it. I didn't even know Dana. I would never have crossed paths with her if DeVante hadn't asked me to take her to the store. But she got into the car with me and now she was dead and I was alive. I was in and out of my head, hopped up on painkillers, but I thought about Dana constantly. I mourned her and wondered about her: who she was, where she was from, what *her* dreams had been. And I wondered about the moment in time where our lives had become so tragically intertwined: Had she suffered? What could I have done? Was it all my fault? Or

would that accident have happened if any of the guys from Da Bassment had been behind the wheel?

**DANA'S DEATH MADE** me more determined than ever to get away from DeVante. He traveled a lot and was away from the house often, but his lackeys were ever present, keeping an eye on us and the music that we made in the sweatshop that was the basement.

One person I had gotten very cool with was Jimmy Douglass, the in-house engineer. A great producer is only as good as his engineer, because it's his fine-tuning and attention to detail that make a song go from good to great. Jimmy was one of the best in the biz. He was older and wiser, and I learned a lot about the music industry just from having casual conversations with him.

Jimmy saw what was going down with DeVante and would sometimes shoot me a look that let me know he didn't approve of what was going on. One afternoon, Jimmy invited me out to lunch at a local coffee shop to talk about it.

But we were both so paranoid about DeVante's boys and their associates that we didn't dare to speak frankly, even away from the house. The word *groceries* was our code for *music*.

"So if I run to the store and get the groceries," I said, "you'll meet me out there? And help me carry them?"

"Absolutely," Jimmy said.

"You'll put the groceries away for me and keep them safe?" I asked.

"Without a doubt," Jimmy said.

So I knew Jimmy was on my side. If and when I broke out, I'd have an engineer to help me put the pieces of my music career together. Everything must've been coming to a head because that night, I got a call from Missy.

"I'm out," she said as soon as I picked up the phone.

"You're leaving?"

As much as we'd talked about it, I couldn't believe it.

"Forget DeVante," she said. "Tim, he's just using us. He's never going to put us on."

I was so shaken by the fact that I might not have Missy by my side that I forgot all about who might be listening to the conversation and I didn't even bother to use a code word. She was like a sister to me and more; she was my true north, the person who kept me creatively and emotionally in check with my best self.

"Missy, I have beats and tracks I made. I'm not going to just leave them here. How else are we going to get another shot working with a major producer? I'm not sure if I'm ready to leave yet."

She sighed and brought up a subject I knew she didn't like to discuss. "You know what I went through with my parents," she said quietly. "I saw my dad beat up my mom one too many times. My mom kept saying she was leaving but when we finally left it was like it was almost too late; the damage to both of us had been done so hard, we could never fully recover. I'm getting the same vibe from DeVante. He's always cursing someone out, always threatening someone. The way he treats you and the rest of the crew is just wrong. And what are we getting out of it? All of these years and we still don't have anything."

"DeVante's got issues, but who doesn't?" I said, making excuses.

You've heard of Stockholm syndrome, right? After more than three years, I was bonded to DeVante in ways that it would take me years to figure out.

"Forget that!" Missy said. "You can re-create all of your music. We can find another way. Just get the hell out of there."

"Where are you now?" I asked.

"Upstate New York," she said. "And I'm not coming back to Hackensack. Jodeci have a show in Manhattan tomorrow night. As soon as they hit the stage, I'm out of here. You need to get out of there too. Like now. Take what music you can, leave the rest."

Then I asked the question that had gnawed at me ever since I'd begun daydreaming about escaping from Teaneck. I had been living in an apartment or a house that DeVante had rented for me since I was eighteen years old. I'd come straight from my mother's house to his. I looked like a man. I talked like a man. But I wasn't my own man. Not yet. Not truly.

"Where am I supposed to go?" I asked Missy.

"Come to New York with me," she said. "Go back to Virginia. It don't matter. We just gotta get away from this dude. Period."

I took a deep breath and tried to stall. "I think things might be changing. I'm hearing that DeVante might be getting a deal with Sony and he's shopping stuff around. I'm prepared to leave. But I'm not leaving just yet."

"You are insane!" Missy said, exasperated.

"He's talking about taking us on tour," I mumbled.

"You still believe anything this dude says?"

"I just don't want to walk away without having my shit in order," I said finally.

"Fair enough," Missy said. "Look, I'm not telling anyone else to leave. It's just that you're the person I'm closest to. And I just wanted you to know that my gut says that this is done. I think you should leave *now*."

# 12

# TEN BEATS A DAY

After Missy left, I packed my suitcase when none of the guys were looking and started sleeping with it next to me. I told nobody but Jimmy about my plans. The crew was rotating but by then, the only ones who were left were Ginuwine, who was traveling with DeVante, trying to get a deal, and the guys from Playa, including Static, with whom I'd cowritten the music for "Pony."

I got a call from Missy a few days later.

"Where you at?" I asked.

"Home," she said.

I dragged the phone as far as I could into the studio so no one could hear me.

"You okay?"

"Better than okay," she said. "I feel free. I'ma go to Philly soon to work with that girl group I told you about."

"Who's producing them?"

"I don't know yet," she said. "But whatever happens, I'll have you involved. But first you've got to get out of your situation."

"I know," I said. "I'll keep you posted."

As the weeks went on, I noticed there was a weird, frantic vibe in the air. It was like Missy's departure had been a sign—not just to me, but to all of the guys—that if we wanted to survive, we needed to get off of this sinking ship. We averted our eyes whenever we saw DeVante and we worked hard to stay out of his way. He'd taken to wearing these satin Hugh Hefner–style slippers in the house. The slippers made a *swish swish swish* sound against the hardwood floor so you always knew when he was nearby. When you heard that sound you knew it was time to look busy and not like you were planning to escape from Attica.

It's hard to explain how big DeVante and Jodeci were at this time. They were at the top of the charts, along with Boyz II Men. But unlike Boyz II Men, Jodeci was writing and producing just about every track they recorded, in addition to their writing and producing for other artists, like Tupac. DeVante had credibility as not just an artist but as a music executive.

One night Jimmy took me out to dinner at the local diner and tried to give me the same "get out of Dodge" talk that Missy had.

"All of the intimidation and scare tactics are bullshit," he said. "DeVante's got everyone on pins and needles just because he can. You're a gifted artist. The music you're making is like nothing I've ever heard and I've been in the business for a long time."

I just nodded my head and said thanks.

"If you don't leave here, you will be wasting all of your talent," Jimmy said. "All of it."

I tried to explain my hesitation. "I don't have any contacts in the industry, Jimmy. I'm not even sure how I would shop these beats."

Jimmy leaned in close and lowered his voice, pointing a finger at me. "If DeVante's contacts were that great, would you be sitting here after all these years of hard work with no money? Where are your checks, Tim? Why doesn't Ginuwine have a deal? What's up with your deal with Magoo and Larry? This dude is full of it. And he's gonna drag the rest of us down with him. We have to go."

"You're right," I said.

"Think about the song 'Pony,'" Jimmy said. "I know a smash record when I hear it. You, Static and Ginuwine did a great job on that song. DeVante won't even play it for anyone!"

I shook my head. I was surprised by the way that DeVante just let "Pony" sit on the shelf, unheard, when every time we played it in the studio, the whole room went wild like it was Times Square on New Year's Eve.

Jimmy pointed out some of the other production work I had done. "You produced 'True OG' for the *Dangerous Minds* soundtrack. That album sold four million records. Where are your royalties?"

"How much would I get for something like that?" I asked.

I was so naïve, I didn't even know how much I might be owed.

"Depends on what kind of publishing deal you signed,"

Jimmy said. "At least thirty thousand dollars. You need to get the hell out of here."

I took a deep breath. "But where will I start?"

Jimmy looked at me and gave me some of the best advice I ever received.

"Do you have your equipment?"

I told him I did.

"Do you have all those sounds you keep in your head?"

Always.

"Do you have the ability to turn all of those sounds into dope beats?"

I nodded yes.

"Then, Tim, you've got everything you need."

**IT WAS JANUARY** 1996 and I was finally ready to go. Jimmy had copied the masters of the work we'd done when DeVante wasn't around so we'd have the songs we wrote. I'd managed to secret away $70 and I'd used that to book a flight back home to Virginia. I didn't want to roll away from Teaneck on a Greyhound or on Amtrak. I wanted to *fly*.

When I showed up at my grandmother's house, my mother opened the door and squeezed me so hard I struggled to breathe. "Oh, baby," she said. "Am I glad to see you."

I moved into my grandmother's house, where my mother and my brother had been living since the foreclosure on our house. But a lot had changed since I'd started making beats in my bedroom for Surrounded by Idiots. This time I was hyperfocused. I also made a vow that no matter how successful I got, I would never forget the behavior I'd seen in

DeVante's basement. I vowed to treat others with respect and dignity and to demand that treatment for myself.

The first order of business was for us to re-record "Pony." Jimmy hadn't been able to make a copy of that master. So Ginuwine came to the house and we did the whole thing over. Somehow I was able to re-create all the sounds and samples, whistles and belching synthesizers that we had in the original. And Ginuwine's vocals were even better than the first time we recorded them.

Ginuwine and I re-recorded every song that Static and I had written for him, and we sent them to Jimmy to shop. Then I went on a beat-making spree. Ten beats a day, like I was racing Missy to finish a song in an hour. Even when she wasn't around, she inspired me like that.

Back in New York, Jimmy took our music to a man named Michael Kaplan at Epic Records. Jimmy had a mix of tracks that he played for Michael: some Ginuwine, some Missy, some Playa. Michael played each song, looking bored like music execs usually do. He kept fast-forwarding through everything and Jimmy was getting frustrated.

"You need to stop fast-forwarding and listen," Jimmy told him. "The music is good."

"If the music is good, it'll make me stop fast-forwarding," Michael said.

Jimmy kept playing music and then when Michael heard "Pony" he put his hand up.

"Hold up," he said to his assistant. "Rewind that."

The assistant played it from the beginning and a slow smile spread across Michael's face.

"This is incredible. Who's singing?"

"His name is Ginuwine," Jimmy said.

"What the hell is a Ginuwine?" Michael asked. "More importantly, is he signed?"

"No, he's not signed. Not really," Jimmy explained. "He's been working with DeVante for a couple of years."

"Who produced the track?"

"Guy named Timbaland."

Michael turned to Jimmy and said, "Bring both of these to my office. Today. Like right now."

Jimmy was stunned. "But they're not in New York."

Michael stood up, signaling that the meeting was over. "Well then, see you tomorrow."

Michael Kaplan wasn't the head of the urban music department; he worked in pop music. So the fact that he understood what we were doing was a testament to my aspiration from the get-go. Back then, a lot of artists talked about "crossing over," which meant that you were a black artist who had gained white fans too. I always felt like I wanted to make good music, period, and that I wanted the fans—black, white, Asian, Latin, you name it—to cross over to *me*. The songs that my dad had played for me when I was a kid, like Rick James's "Mary Jane" and Prince's "I Wanna Be Your Lover," were mainstream hits that everyone could, and did, rock out to.

I was sitting in my grandmother's house when Jimmy called and said, "I'm getting you a plane ticket to New York City. You need to be here first thing in the morning."

"For what?" I asked.

"Michael Kaplan wants to meet you."

"Who's he?"

"VP at Epic Records, Tim," Jimmy said proudly—and rightly so; he'd promised to hustle on our behalf and he'd come through in days with something DeVante hadn't managed to do in years. "He heard Ginuwine's tracks and he wants to meet you both tomorrow."

"Okay," I said. "I'm ready."

Getting Ginuwine to the meeting would prove more of a problem. He was in LA with DeVante, and if DeVante knew that an exec was interested, there was no way he'd let him leave. Ginuwine was going to have to sneak away. That was going to take some time.

The next morning, Jimmy and I met with Michael Kaplan. He was joined in the meeting by Polly Anthony, another executive at Epic at the time. They both complimented my sound and told me how unique they found my production style.

It was such a bizarre feeling. After making beats for ten years and never knowing if it would amount to anything, these record business folks were telling me what I had only hoped all along—that my catalog of sounds was valuable and that there was something special about the way I put the music I heard in my head together.

"I haven't heard anything like your sound in a long time," Polly Anthony said to me. "It's both really classic and really fresh at the same time. Where are you from?"

I told her Virginia.

"And how did you end up working with DeVante?"

"Through my friend Missy Elliott. She sings and raps too." It was important to me that at my first big record company meeting, I made sure that I let them know that Missy

was an integral part of my music and that they needed to be down with her too.

"Well, we want you to start working with some of our artists, immediately," Polly said. "And we really need to find this vocalist Ginuwine. We love him."

Getting Ginuwine to New York proved to be challenging. DeVante got wind of the fact that some execs had heard some of the Ginuwine tracks, though he didn't know which execs at which label. All of a sudden, getting Ginuwine signed became a top priority. DeVante set up meetings with execs in LA and he kept Ginuwine under virtual house arrest.

Jimmy and I managed to sneak a call to him and Ginuwine seemed genuinely distressed. "DeVante's got this place locked down like a damn fortress," he explained. "I can't take two steps without someone all in my face, wondering where I'm going."

Michael and Polly kept asking to meet Ginuwine and we kept stalling, until finally DeVante brought Ginuwine back to New York and on a busy city street, Ginuwine gave him the slip. He literally walked away from DeVante like a defector from a communist country, with nothing but the clothes on his back. He walked into Epic Records, met with Michael Kaplan and walked out with a deal. Which meant I was about to become a producer with real tracks to my name.

# 13

# BABY GIRL

After Ginuwine was signed and we completed production on his album, I went back to Virginia. Missy and I worked on a few tracks together and we had written a song, on spec, called "Sugar and Spice" and sent it off to the label of a girl group we knew called Sugah. We didn't have very high expectations, but we did what we always did: wrote something we loved and prayed that somebody would feel it too. The year was 1996. Missy and I were both twenty-four years old.

When the call came in from Jomo Hankerson, I was surprised, to say the least. He said, "Aaliyah heard your track 'Sugar and Spice.' She wants to meet with you and Missy. We want you to come down. Meet with Barry. See if it's a good fit."

I knew who Barry was. Barry Hankerson was a onetime television producer from Detroit who had quietly, and under the radar, built a career in music, managing artists from the Winans to Toni Braxton and R. Kelly. He was, in many ways, the antithesis of

executives like Puff Daddy. He liked to keep a low profile. Everyone in the music industry knew about him. Few people actually *knew* him. He was also Aaliyah's uncle.

Aaliyah was beautiful with a style that was all her own. She had only been fourteen when she released her debut album, *Age Ain't Nothing but a Number*. Propelled by the sales of her first single, "Back & Forth," the album went triple platinum. There had been a great deal of controversy surrounding the first album. R. Kelly was the lead producer on that album and rumor had it that he had started an affair with Aaliyah, despite the fact that she was seriously under-age. Court records would later show that the two had eloped when she was just fifteen, although the marriage license said she was eighteen.

A chance to work with her was huge. I called Missy and she was amped too. "Tim, this is crazy!" she said, half laughing, half screaming. "Dog, this is what we've been dreaming of. Aaliyah? I love her music!"

Jomo flew us to Detroit and we met with the executives on the team. Blackground Records, Jomo and Barry's label, had broken ties with Jive, which had released Aaliyah's debut. They had a new deal with Atlantic and they were looking for a whole new sound for their star artist.

A few minutes into our meeting with Jomo, Aaliyah walked in. It's hard to describe it, but from the moment she entered the room, both Missy and I felt like we'd known her our entire lives.

"Tim, Missy," she said. "I'm Aaliyah. It's nice to meet you both."

Her smile was wide and everything about her was warm and welcoming.

"I really like what you and Missy have been working on," Aaliyah said, settling into an armchair in the studio lounge. "I really want that edgy, off-center style for my next album. I don't want to play it safe."

Missy and I had brought a track with us. Something we thought she might like.

Although usually I'm super quiet, I had no problem speaking up with Aaliyah. "We wrote you a song," I said. "Can we play it for you?"

Aaliyah beamed at Jomo. "He's got tracks! He didn't come to chitchat. He came to play music." Then she turned to me and said, "Right down to business. I like that. Let's hear it."

We went into the studio and I cued up a beat that had a slow but danceable groove. Missy had already written the lyrics and recorded the vocals as a reference so Aaliyah could hear how it should sound. The song was called "If Your Girl Only Knew." And from the beginning, we felt like it was a great sample for our meeting. Aaliyah might love it or hate it, but at least we would have presented a piece of music that was truly representative of our sound. The lyrics were *so* Missy:

> *If your girl could only see*
> *How you be calling me*
> *Getting fresh with me*
> *She would probably leave you alone*
> *She would probably curse you out and unplug her phone*

*I bet she'd be glad that you was gone*
*And then she wouldn't have to worry*

My grandmother used to talk about how when she was a young woman she and all of her friends loved a book called *Peyton Place* because it told you, in juicy detail, all the dirty things that were happening behind the white picket fences on all of those pretty, Anywhere USA, tree-lined streets. Missy's lyrics often have a similar quality. You feel like she knows what's going on behind all of the closed doors, what women say they want, what they really want and the lengths they'd go to for Mr. Right and Mr. Right Now.

Aaliyah could tell right away that I wasn't going to give her the straight-up, classic R & B beats. I was drawing from my catalog of sounds and in my songs, you're as likely to hear the sound of oil sizzling in a cast-iron pan and the pounding of a basketball on a concrete court as you are to hear a high hat or a bass drum.

We played "If Your Girl Only Knew" for Aaliyah and she loved it. So much so that halfway through the song, she got up and started dancing to the beat.

Missy and I looked at each other in disbelief. So many years of the road being hard. How could it be that within a few short months of emancipating ourselves from DeVante, things could be going so easily?

Aaliyah stopped dancing for a moment and looked at us and said, "You two have something special and I want to be part of it."

Jomo arranged to put Missy and me up in a nearby hotel and we started working on "If Your Girl Only Knew" right

away. In the studio, Aaliyah explained what her goals for the new album were. She said, "See, this is the thing. I'm feeling really good about this second album. I feel pressure too. The label wants it to be bigger. I want it to be bigger too. I also want it to be *better*. I want to be challenged by all of the producers and writers who are working with me. You know what I mean?"

We did. Although we were just getting our feet wet in the industry, Missy and I had ten years of experience working together. We pushed each other. We kept raising the bar for each other. When we started working with Aaliyah, we all recognized in each other not just a desire to stand out among the crowd but a commitment to excellence.

Soon after our arrival in Detroit, Aaliyah started calling me Teddy Bear and we started calling her Baby Girl. She realized pretty quickly that all she had to do was call me by my new nickname to get me to do whatever she wanted.

"Teddy Bear," she'd say, "we should stay in the studio a little longer. Knock out this song."

No matter how tired I was and no matter how long we'd been there, I'd stay and work until we were ready to drop.

After we were done recording "If Your Girl Only Knew," we handed it to the executives at Atlantic and waited to hear their response. We'd done the one song they'd allotted to us and now there was nothing to do but wait. It was excruciating. Aaliyah was just as nervous as Missy and I were.

We were having dinner in Detroit one night and Aaliyah said, "What's taking them so long? This song has to make the album. And it should be a single. Maybe even the *first* single."

Missy and I were afraid to get our hopes up. "Let's not get carried away," Missy said. "The beat is sick. We know that. But it's so different from what's on the radio right now. Maybe the label won't be ready."

Aaliyah shook her head. "They'll pick it. I know it. I'll *insist* on it."

I just smiled. The way Aaliyah was willing to go to bat for us was astounding. I felt like I'd known her for years, not just weeks. Twyla Tharp, the choreographer who has worked with some of the most creative people in the world, from Mikhail Baryshnikov and David Byrne to people like Billy Joel and James Brooks, believes that "all collaborations are love stories." I've produced work now for literally hundreds of artists and I know this to be true. When the work works, when I break out my catalog of sound and an artist brings her or his true spirit to the studio, it is a love story. Sometimes it's Romeo and Juliet. Sometimes it's Captain Ahab and Moby Dick. Sometimes it's Scarlett O'Hara and Rhett Butler. Sometimes it's Butch Cassidy and the Sundance Kid. And sometimes, like in the case of me, Aaliyah and Missy, it's like that old Sly and the Family Stone song says, a family affair.

The next day Barry called to say, "We love this song. It's gonna be a single. Ready to start working on another track?"

I was ready for more, and next up would be a song we called "Are You That Somebody?" I used a sample of a baby cooing from an old electronica classic, a Perrey and Kingsley track from the 1960s called "Countdown at 6"—because Aaliyah had already started feeling like family to us, which

is why we called her Baby Girl—and you can hear it on the album when I come on with my rap:

> *Baby Girl,*
> *I'm the man from the big VA*
> *Won't you come play round my way?*
> *And listen to what I gotta say*
> *Timbaland*
> *Don't you know I am the man*
> *Rock shows from Virginia to Japan*
> *Have people shaking shaking my hand*
> *Baby Girl,*
> *Better known as Aaliyah*
> *Give me goose bumps and high fevers*
> *Making pluyu haters to believers*
> *Don't you know*
> *Gotta tell somebody 'cause. . .*
> *'Cause I really need somebody (uh-huh)*
> *Tell me are you that somebody! (Say what!)*

The hook on "Are You That Somebody?" was so simple—*Are you that somebody? Because I really need somebody*—but Aaliyah's delivery made it a classic. It's a song that lives on and on, one that has been sampled and referenced by everyone from Drake and Lil Wayne to Australian artist Gotye to Banks, who did an acoustic version of the song on the BBC.

The summer of 1996, Aaliyah dropped her sophomore album, *One in a Million*. The record was everywhere. It went triple platinum in the US and sold over eight million copies

worldwide. Aaliyah often spoke of the album as being her *Control*, the album that Janet Jackson had made when she was around the same age. That album had established Janet's independence and creativity in a way that set the stage for a stunning career (no small feat when your brothers are musical legends). Aaliyah had grown up listening to *Control* in much the same way that I had been weaned on Rick James and Prince. Aaliyah spoke of her desire to record with her idol whenever a microphone was thrust into her face, and Janet had gone on record saying that she would welcome the opportunity to record with Baby Girl too.

She was so young and yet she changed the face of R & B music. She was an urban girl but she had a lot of mystery to her; you could never pigeonhole her. From the way her hair swooped over her eye to the giant sunglasses to her oversized jackets that revealed her rock-hard abs, the music industry had never seen anything like it. The spring after *One in a Million* became such a massive hit, she graduated from the Detroit School for the Fine and Performing Arts. Then she recorded the title song for Fox's animated film *Anastasia*. The song was nominated for an Oscar and she became the youngest singer to ever perform at the Academy Awards. But she wasn't about to become a typical Disney-like princess. The next year she made a movie with Jet Li, a modern-day retelling of *Romeo and Juliet* called *Romeo Must Die*. And then after rocking it out in a martial arts movie, she went over to the dark side, playing an ancient vampire queen in Anne Rice's *Queen of the Damned*. She had the superstar shine of Beyoncé, the rock-and-roll edge of Rihanna and a style that was entirely her own. Everything she did was

new and had never been done by a teenage girl, of any color, in the industry before. She had all the talent, but what she had above and beyond anything was an instinct—an instinct for choosing the right projects, an instinct for transforming herself—and a curiosity that made her say yes, why not, in an industry known for playing it safe and profiting from giving the people the same thing again and again and again.

Aaliyah, with her sweet, sultry soprano, was like a piece of the puzzle that we didn't even know was missing. Like Missy, she loved the language of real women. She loved the playfulness and the seduction, the secrets and the scandals that made love so rich and so real. Like me, she loved listening to the world. She had a particular appreciation for all of the sounds that I brought onto a track and the way I mixed them together. Sometimes, when we were working on a song in a studio, it was like the music was a snow globe that we'd shaken up: the raindrops and the vocal melodies, the whistles and the hand claps, the talk boxes and the beat-boxes, the world in sound swirling around our heads as our souls looked on in wonder.

# 14

# JIGGA WHAT?

**O**ur work with Aaliyah led to more producing opportunities, but in the back of my mind, I started thinking about doing something more personal. I've never claimed to be a rapper's rapper. But I can do a little something on the mic. I decided my solo album would actually be more like a compilation album of all of my favorite artists at the time. In 1998 I dropped my first solo album, *Tim's Bio: Live from da Bassment,* a nod to my days with the Da Bassment crew. I was twenty-six years old and had just begun to develop my friendship with Jay Z, so I was thrilled when he agreed to do a track called "Lobster and Scrimp," a playful ode to the good life. Static, who was my cowriter on "Pony," appeared on a few tracks, and I brought in Kelly Price, a new vocalist with an amazing voice. And of course, I had my family with me: Missy, Aaliyah and Ginuwine all generously contributed tracks as well.

I had heard a young rapper on the radio in Atlanta so I invited him to rhyme on the album too. That youngun was Ludacris, and

he would go on to have a multiplatinum career of his own. I'm proud to say that I was the first person to put him on a record.

I'll be honest. I was disappointed when *Tim's Bio* didn't top the charts or rack up millions in sales. But I'm a creative person. My job is to make music—constantly. You can't do everything for the money. You sure as hell can't do it all for the fame or the praise. Sometimes you write a song or make a beat because it feels good and it makes you smile. Maybe the thing you wrote that didn't sell sets the musical groundwork for an idea that you develop later. Sometimes it's the later thing that explodes, and even though the critics rarely connect the dots, you start to understand: there was no way for you to get to point C without getting to point A and point B first. My journey is my own, and as long as I'm learning and doing new things, then I'm growing. And as long as I am growing, I'm good.

Once I got done with my solo project, it was time to get Missy ready for her sophomore album.

"I already know what I'm calling this album," Missy said the minute we got into the studio.

"Lay it on me," I said.

*"She's a Bitch,"* Missy said.

"Are you serious?" I asked, raising an eyebrow. "You're not serious."

Missy spun around in her chair. I could tell she was a ball of nervous energy. "I'm dead serious, Tim. I wrote the lyrics to a song called 'She's a Bitch' and I want the album to have the same name. Cue up some beats so I can spit the song for you."

I played a simple beat and Missy started rhyming for me. I could tell that she was going for a darker, more raunchy style than her first album. *Supa Dupa Fly* was all about being laid-back and playful. We were just so happy to be making a bona fide Missy Elliott joint. This time around, there was pressure. People would want to know if we could reproduce the magic. We hadn't even started working and I could tell the pressure was getting to Missy. I could hear it in her lyrics and her delivery. She was stressing.

I stopped the beat. "Missy, relax. Forget about the last album."

"How can I forget?" Missy said, cutting her eyes at me. "No one at the label will let me forget."

I looked around the studio. "No one from the label is here. It's just you and me. We're about to do what we always do—make good music. If people like it, great. If not, oh well and on to the next."

Missy wasn't comforted. "That's just it," she said. "If this album doesn't do well, there might not be a third. I keep hearing about artists who got cut off the roster because of a sophomore slump."

I sighed. Her energy was so different from what I'd been expecting to work with that day. I wasn't expecting all of the stress and I was still relatively new to the game. As a producer with a growing string of hits under my belt, my brand didn't depend on the fate of one album. But Missy was both a writer and a producer and an artist. I know she valued her work as a singer and a rapper just as much as she valued her work behind the scenes. The pressures on her were different and I had to recognize that.

I got up and sat next to her. "It's not that I don't get the pressure. I see it. I feel it. But you're going to kill your creativity if you keep dwelling on the label, the critics and the sales. Let's just focus on how far we've come, how lucky we are and how much we love to make music."

Missy smiled. "You're right. You are sooo right." I could feel her energy and optimism bubbling up. She shook it off and we got back to work. I created a slow, haunting beat for a song Missy wrote called "All N My Grill." We layered it with vocals by a singer called Nicole Wray. In the original, we had Big Boi from Outkast spit a rhyme. The European version featured a French rapper named MC Solaar. It was so crazy how that little song went all around the world. Boy George remixed the single for the UK. Missy and I remembered being kids and dancing around to songs like "Karma Chameleon." Now he was remixing *our* tracks. Unbelievable.

As close as Missy and I were, we didn't talk about our relationships very often. In a lot of ways we were like an old married couple. The music was our baby. Minding that baby, raising that baby, was more than a full-time job. So when Missy came in with the lyrics for a song called "Crazy Feelings," I had to take a step back. She didn't just have the nervous energy of doing her second album. She'd been through something. Put her feelings out there and gotten her heart stomped for the effort. We wanted a vocalist with true chops to join Missy on the album, so we reached out to Beyoncé. At the time, the Queen Bey was just eighteen years old but already on her way to making girl-group history with Destiny's Child. The day she came to the studio we were both struck by how poised she was. She arrived early, not just on

time. She was soft-spoken and kept to herself. But when it was time for her to sing, she blew the house down.

"I like the way this is coming together," Missy said when we were finishing up the album.

"Of course," I said. "You know how well we work together."

"But we have to finish soon," she said, looking worried. "Elektra keeps hounding me to hand in the album."

"We spoiled them!" I said. "Gave them the first album in two weeks. What were we thinking?"

Missy and I both laughed about how quickly *Supa Dupa Fly* had come together. But the reality was that album was like something that had been growing inside of us for years, from my bedroom in Virginia Beach to DeVante's basement to the Detroit studio where we made magic with Aaliyah. That's why I say you can never judge an artist at first blush. There's no way to know, until you get in the studio, what she has inside of her, all the ways that life has been grooming her and growing her for the moment you're about to record on wax.

One afternoon I was working on Missy's album when Jay Z dropped by the studio. Since the success of "Jigga What," we had kicked it from time to time. When he came in, I was parked at the mixing board.

"Tim, you gonna kill yourself, man," he said, smiling. "All this work. Let me take you to Atlantic City or something."

I shook my head. "A closed mouth don't get fed, bro."

He pulled up a chair. "Okay, then let me hear what you got. Some of that top secret shit."

I played several tracks for him. Jay nodded his head. He seemed to like what he heard. Sometimes he'd give a brief

comment, let me know what he liked more than other things. As usual, I had this one beat that I just couldn't get a grip on. I'd been playing with a sample called "Khosara Khosara," a beautiful Egyptian melody performed by a famous singer named Abdel Halim Hafez, who was like the Frank Sinatra of Arab music. I couldn't find the right flow to match what was going on in the song. I had flutes whistling a melody and I was ratcheting that against a bounce bass line. But it was hard to wrangle. At the moment that Jay was in the studio, the track was playing me, not the other way around. I figured if anyone could tame this beat, it would be Jay. So I played it for him.

I could tell that he liked it because he stood up to listen to it.

When I was done, he asked, "Yo, what are your plans for this one?"

I shrugged. "Still thinking on it. I dig it but I don't know what to do with it."

Jay said, "You need to give it to me. Dog, I need this. I could do something with this."

Jay was one of those artists who always raised the level. If he heard something in a track, he was going to put some heat on it. When I looked at him, he had that faraway look in his eye like he was already writing the song in his head.

"You got something?" I asked. "Already?"

Jay just smiled and made his way into the booth, gesturing to the engineer to cue up the beat.

Within hours, the song was done and we were mastering

the track. I was sitting at the board, a grin on my face, singing along with Jay as we played back his vocals.

Jay Z nailed it. He always does. He has this God-given ability to find the appropriate flow to ride over any beat. Then we brought in Bun B and Pimp C, known collectively as UGK, in to round out the track. The way their Southern drawl floated over that Egyptian-inspired beat just blew my mind. It felt all kinds of right. Jay Z called the song "Big Pimpin'." But he could have titled it anything and it would have been perfect.

That song went on to become the most successful single on Jay's album *Vol. 3 . . . Life and Times of S. Carter*: it was number one on the Top 40 chart and *Rolling Stone* named it to their list of the five hundred greatest songs of all time. Later, when Jay was working on his book, *Decoded*, he expressed some regret about the lyrics to the song. He said, "Some [lyrics] become really profound when you see them in writing. Not 'Big Pimpin'.' That's the exception. It was like, I can't believe I said that. And kept saying it. What kind of animal would say this sort of thing? Reading it is really harsh." Honestly? It just makes me admire him even more. Making records is all about the moment. You make a beat, you write a rhyme, you capture that moment in time and it's a letter in a bottle. Sometimes, years later, you go back and you play a track and it's like reading the diary of a you that you can barely remember. Doesn't mean that the old you was bad or someone to be ashamed of. Thank God we have our music. For a whole generation of artists, from Jay and Beyoncé to me, Missy and Ginuwine, we've got this exqui-

site vault of music that captures who we were and how we felt. It's like those pencil nicks on the kitchen wall that your parents make to show how tall you're getting. Our nicks have beats and melodies, but it's the same thing. They show us how much we've grown.

# 15

# ARE YOU THAT SOMEBODY?

The title of the song "Try Again," which we wrote for Aaliyah, is ironic, because I couldn't stop fiddling with the bass line. It was in my head so much that I actually began to dream about it. There was something nagging at me that I couldn't quite work out. Aaliyah told me to chill, Missy begged me to stop overthinking it, but I couldn't let it go. Finally, I relented. After all, just as Aaliyah sang in the song: *If at first you don't succeed, dust yourself off and try again.*

It was 2000, the start of not just a new year but a new century. Aaliyah had just landed her first big movie role, opposite action star Jet Li in *Romeo Must Die*. She was only twenty-one but Baby Girl had so much talent that she'd talked her way into being executive producer of the film's soundtrack. I started the track by quoting the opening lines to Eric B. and Rakim's "I Know You Got Soul":

*It's been a long time, since I left you,*
*Without a dope beat to step to*

Then I intro'd Aaliyah by literally calling her onto the track: "Baby Girl." Kelefa Sanneh in the *New York Times* wrote that on the song, Aaliyah "seems to be playing a game with the bass line, matching its swells and fades, twists and turns." He also wrote that "'Try Again' helped smuggle the innovative techniques of electronic dance music onto the American pop charts, and it established Aaliyah as pop music's most futuristic star."

In many ways that song epitomized all the things Missy and I were striving to do in our music. We wanted to make music that felt both instantly familiar but also one step ahead. The listening public responded immediately. "Try Again" became the first song to hit the top of the *Billboard* Top 100 based solely on radio airplay. Aaliyah was nominated for a Grammy and she won two MTV Video Music Awards for the video. Baby Girl was shining bright and all of us were benefiting from her light.

There were two things I learned about the whole "Try Again" ordeal: You have to keep people around that you trust to tell you to let go. Also, sometimes it's good to be wrong. I was overthinking the track to the point of obsessing. Surely I could have scrapped it and moved on with other songs. Maybe I would have tinkered with it and made some improvements. Or maybe not. In the end it was perfect because it was imperfect. I learned so much working with Aaliyah, but one of the most important things was to trust the organic nature of the process.

**BARRY HANKERSON, AALIYAH'S** uncle, introduced me to Jimmy Iovine at Interscope. I respected what Barry had done with his own label, Blackground, and I was thinking maybe the time was right for me to start a label of my own. Jimmy and I met and discussed the foundations of what would become Beat Club.

The money was literally pouring in. If I weren't cashing every check and monitoring every royalty statement, I would have thought someone was counterfeiting bills and filling my bank account. It was that much loot. The flow was that steady. But the funds were legit and for the first time in my life, I could spend without hesitation. I was twenty-eight years old.

I had been dating a girl named Angela from back in Virginia Beach and I bought her *tons* of stuff. I started becoming a regular customer of Jacob Arabo, aka Jacob the Jeweler, who was *the* go-to guy for bling in the hip-hop world. As Jay Z rapped in "Girl's Best Friend":

> *I took you out of Jacob in clusters*
> *Busters, they wanted to rush us*
> *Love the way you sparkle when the sun touch ya*

But what really got me excited were the cars. I went all out, picking out cars like a kid picks out ice-cream flavors. At one point, I had a Mercedes CLK, a Benz CL600, a Ferrari F430 and a Lamborghini convertible. Every other month, I bought a new car. I bought a house in Virginia Beach. I bought a house for my mother. I had everything I

could have possibly wanted. I wasn't saving much, but I was enjoying spending and being able to do for my family and the people I loved.

My mother was still my rock and one of my biggest supporters. We talked a lot about my success and what it meant. She was happy to see that the little boy whose prized possession was a Fisher-Price record player was now making music that he loved. But she also had her concerns.

"Tim," she said to me one afternoon, "you know you can only drive one car at a time."

"I know, Ma," I said cheekily. "And I do drive one car at a time. One on Monday, one on Tuesday, you feel me?"

She laughed at that one, but she wasn't going to let me off the hook just yet.

"Don't forget who you are, Tim," she said. "You don't need all these things to be happy. When you were young and we didn't have much, you held on to your music and the music gave you joy. Now your hard work is paying off. Just don't lose track of you."

I thought about what she said a lot in the days after our conversation. If I didn't listen to my mother—who had never steered me wrong—who could I listen to? It was fun to shop and spend, but how much of what she said was true? When was it all just too much?

When I got that insurance bill for $60,000, I realized that yes, I was in fact spending too much. Some of those whips had to go. Sixty K on car insurance? Nah, that was a beat I just couldn't clap to. Unjustifiable.

In an effort to tone down my lifestyle a little bit, I decided that I would buy a Cadillac Escalade and make that

my everyday ride. I was prepared to pay cash for the car, I already knew where to take it to get the sound system right and there was a guy on standby, ready to lace the car with some twenty-two-inch chrome wheels.

I walked into the dealership and it was as if I were invisible. Not a single person made a move to help me, even after I looked at several cars with interest. Any time I tried to make eye contact with someone, they looked away. One woman on the sales floor was openly ignoring me. I could tell that she was assuming I was just looking. Little did she know, I could have purchased every car on that lot.

I grew up in the South, so I'm no stranger to racism. But in this day and age, I naïvely thought things might be different. Finally, the woman on the floor spoke to me grudgingly.

"Can I help you?" she asked.

"Yes, I'm looking for a new truck." I paused. The one I had been checking out before she approached me was kind of fly. "Actually, can I test-drive this one?"

"Test-drive?" She repeated it as if the words were in a foreign language she didn't understand.

"Yes," I said. "I want to test-drive this one right here. See if I like it."

She looked me up and down and said, "*You* want to test-drive this car?"

I was starting to get impatient but I kept my tone even. "Yes," I said. "Is there a problem?"

She hesitated, then said, "Well, we don't really have anyone to go on a drive right now."

I looked around. It was a weekday morning and the floor

was buzzing with employees. Salespeople were chatting it up and chilling. I looked at the crowd of people by the coffee machine, then looked back at her. She seemed to be daring me to disagree with her. Her nonexistent lips were firmly pressed together.

"Can I speak to your manager?" I asked.

Now she was bothered. "I don't see why that's necessary," she said, her voice getting shrill.

"Not a hard thing to do to find him or her myself," I said, walking past her.

She said, "Okay, one minute," and then she disappeared into one of the rear offices.

A few minutes later, the manager came out to talk to me. He seemed like an okay dude, but I had already decided they weren't getting my money. It was the principle of the thing.

"I was prepared to purchase one of your vehicles today, in cash," I told the manager. His eyes widened and he tried to usher me into his office.

"By all means, let me take you on a test drive myself," he said apologetically. "We can try any of the vehicles you want."

I smiled and shook my head. "No, thank you," I said. "Your employee lost this sale. She willfully ignored me on the floor and when I finally got her attention she told me no one was available for a test drive, which is clearly not true. So I am taking my business where it will be respected."

"Excuse me, sir," he said. "I'll be right back."

I could hear him loudly whispering at the woman who had treated me so poorly.

Then he came back and he said, "What can we do to save this sale?"

"Absolutely nothing," I said, walking out of the dealership.

As I got into my car, I could see through the window that the manager was now openly screaming at the woman. I hope that he fired her, because honestly I think that's the only way someone like her would ever learn. But that wasn't my concern. I had stood up for myself.

By August 2001, I began to get caught up in the hip-hop lifestyle. One time I rented a villa in Cancún. There were so many beautiful black women there. Jay Z came through. Jermaine Dupri was one of my guests. And I'll admit it: I was acting like a ho.

I had been dating Angela on and off for a few years when we decided to get married. I'm willing to admit, I wasn't always faithful. But I was ready to put aside the whole player thing and settle down. My parents adored her. My friends and my family were all in favor. But as we started to address the wedding invitations, something was gnawing at me.

"You sure you want to do this?" I asked Angela. I tried to make my voice light, but Angela knew me well enough that she bolted upright in her chair and gave me *the look*.

"Why would I be unsure?" she asked.

"I don't know . . ."

"Wait," she said, clutching a cream-colored envelope in her hand. "Are *you* not sure?"

"Who says I'm not sure?"

Angela went back to addressing envelopes, but she kept giving me the side eye and it was not like I didn't deserve it.

I had questions. Was I ready to get married? Did I have what it took to be a good husband? And just as importantly, did Angela have what it took to be a good wife?

There was a part of me that wondered whether Angela loved Timothy Mosley, the chubby shy guy from Virginia Beach, or was infatuated with Timbaland, a producer with millions of dollars in the bank and a slew of hit records under his belt. When you're in the spotlight and you're starting to accumulate serious wealth, you begin to wonder what people's motives are. Angela hadn't been around before the money. Would she be around if there were no money? I wasn't sure. These questions had more to do with my uncertainty than they had to do with her intentions and good character.

I loved her. She was sweet, caring and a genuinely impressive woman. So I put my doubts aside and moved forward with our plans to marry. I told myself, *You can't call it off when the invites are already in the mail.* So I moved forward. I bought my tux. I got my groomsmen together and I got ready to jump the broom.

But first I had to finish up a recording session. I was at the board in New York when a friend brought a young woman named Nia into the studio to hang out. It wasn't unusual for people to hang out at the studio while I was working. Making music is a social business and you never know when a surprise drop-in might lead to a hit song, like when Jay swung by and we ended up recording "Big Pimpin'."

Often the girls who come around have a groupie vibe. They're looking to date or seduce someone who might be able to give them the lifestyle they'd like to become accustomed to. But that wasn't the case with Nia. She was shy and

soft-spoken but clearly confident and independent. I was a week away from getting married and I knew I wanted to get to know Nia better.

I knew it was wrong. But hours after I introduced myself to her, Nia and I were still talking. About everything. Music. Life. Relationships. Family. We had so much in common, it scared me. After my session was over, we ended up at a diner together, still talking.

"You realize we have something here," I told Nia.

She smiled and shook her head. "I don't date industry types. Not anymore. Y'all are players."

I protested. "You can't lump us all together. We're all different."

Nia put her fork down and clasped both of her hands together. "Oh yeah?" she asked. "Do you have a girlfriend?"

I sputtered and tried to think of how to answer, repeating the question to buy time. "Do I have a girlfriend?"

She wasn't having it. "Oh, you heard the question. Tim, do you have a girlfriend?"

I thought about the wedding in a week. Maybe all of my jitters weren't just prewedding butterflies. Maybe I knew I was going to meet my soul mate and maybe I knew that Angela wasn't her.

"I don't just have a girlfriend . . . ," I began to explain.

Nia stood up. "A wife? We're done here."

"No," I said, putting my hand on her shoulder and gesturing that she should sit down and hear me out.

"I'm not married . . . But I'm engaged to get married."

"I knew it," she said, reaching for her purse. "Players. Every last one of you. Bye, Timothy. It really was nice talking to you."

The next day I went back home to Virginia and told Angela that I thought we should see our pastor again before the wedding.

"Why do you want to see the pastor?" she asked. She had a book with all of the wedding details in it. She was fiddling with the seating arrangements and I could tell that she was more annoyed at being interrupted than anything else.

"Why not see him?" I asked. "That's what he's there for, right? Counseling."

Angela looked up from her book. "But we did the premarital counseling that the church recommended."

I tried not to sound like something was wrong. "So what? I'm recommending that we do a little more."

I called the church and the pastor agreed to see us that afternoon. Angela had, over the course of a few short hours, worked herself into a frenzy. I didn't blame her. Our wedding was just days away. By the time he escorted us into his office, she was in tears.

"Angela, what's wrong?" the pastor asked.

"Tim is not sure if he wants to marry me. The wedding is in two days and I'm devastated."

"Tim, is this true?"

This was my pastor. I had to be honest.

"Sir, I'm sorry, but I've been having doubts and I don't think it's just cold feet. I'm worried that Angela may not be the right match for me."

"What makes you say that?" he asked.

I held my stomach. "My gut says something isn't right."

The pastor looked concerned and Angela continued to sob. I couldn't even comfort her because I was the one who

was breaking her heart. We left the pastor's office with no sense of resolution.

But by the time we got home, I knew that I wasn't getting married that weekend. I just had to find the courage to tell her. Remember when Pharrell came and told me that he couldn't be in my band anymore? How he'd come and talked to me like a man and how much I'd respected him for it? This was a different situation, but it's the same principle. Now it was my turn to speak my truth and be honorable in my honesty.

"Angela, I'm sorry," I said. "But we're not getting married this weekend."

Her eyes widened and I could see her cycling back and forth between grief and rage. I thought about how back when I was a kid everyone called Al Green Al "Grits" Green because a scorched lover had poured a pot of boiling-hot grits on him when he was in the bathtub. I hoped that Angela would take the news better than that.

"Oh hell no!" she screamed. "What do you mean we're not getting married? *You* asked me to marry you. *You* gave me a ring. *You* said, 'I love you, I want to tell the world. I want you to be my wife.' *You* led me on while I picked out china patterns and a big white dress that now I want to shred and burn. I have family coming from all over the country this weekend. What am I supposed to say to them?"

"Put it all on me, baby," I said. "Tell them I changed my mind."

"Don't call me baby," she said. "And you can change your mind later after we have the wedding that everyone we know is expecting us to have."

The moment she said that, I didn't care anymore. I'd waited too long. I hadn't handled it well. But I'd handled it. I'd rather cancel a wedding than claw my way through a divorce. I started to pack a bag and tried my best to block out the sound of Angela's tears. They reminded me so much of my mother's when my father had left her. Now there was a parallel track to that soundscape. Angela's wailing. Tears that I had caused.

I stood at the door and she stared at me in disbelief. As if she didn't expect me to leave, as if she thought we'd fight it out and then just go through with it.

"Where do you think you're going?" she asked.

"New York," I said. "I'll call my family and friends. Of course, I'll pay for everything."

"You damn well better," she hissed.

"Angela," I said. "I'm sorry."

Then she spoke very slowly and she said, "Don't you ever, ever, ever speak another word to me for the rest of my life."

I wish I could say that I felt guilty. But as I bought a last-minute plane ticket and then boarded my flight, all I felt was relief. The first thing I did when I got to New York was call Nia.

"Aren't you supposed to be married or something?" Nia asked as soon as she answered the phone.

"I didn't get married."

"I hope it wasn't because of me," she said. "Because I barely know you."

I told her it wasn't because of her but I also told her that I wanted to get to know her better. It was hard convincing her but, over a few months, I finally convinced Nia to be my

girlfriend. We dated for a few years, years in which I grew up—a lot. But when people started talking marriage, I had the same sense of doubt. So Nia and I broke up.

My friends always told me that when you meet your soul mate, you know in an instant. It's like all the years you spent running away from relationships are reversed because you don't want to just date her or sleep with her or hang with her until the early morning. You look at her and you know that's the face you want to wake up to for the rest of your life. You feel the call of forever and you have this desperation to lock it down before another guy makes a move and everything you dreamed about is lost. Gone.

It sounded a little dramatic, but then it happened to me. It was my favorite kind of business trip. An island paradise. Panels during the day. Parties every night. When the team from Interscope asked if I wanted to attend a music conference in Jamaica, I didn't hesitate to say yes. And just to make sure that I didn't work *too* hard, I brought along my boys Magoo and Larry from Virginia Beach.

I was standing with my boys in the lobby of the hotel when I saw her. It was like there was a light shining behind her. She lifted her head and I literally had to do a double take. Everything about her was beautiful, from her skin to her body to the way she carried herself.

"There's my wife," I told Magoo and Larry.

"What?" they both guffawed. After all, they both had groomsmen tuxes in their closets from when I'd canceled my nuptials to Angela just a few years before.

I pointed her out. "That's the woman I'm going to marry."

"Do you know her?" Larry asked.

"I don't need to know her," I said. "She's the one. Yo, someone tell her to come over here."

Larry walked over to her and I could see him talking and pointing at me. I waved. She did not wave back. I saw her tell Larry something and from the look on her face, I didn't think I was going to like it.

He grinned as he walked back over to me and Magoo. "You got yourself a live one, partner," he said. "She wants you to know that if you would like to talk to her, you need to go over there and introduce yourself."

I looked over and saw she was walking out of the hotel. All of a sudden, it was like my pride was on hold. I literally started jogging to catch up with her.

"Excuse me," I said.

"Yes?" she said. Her voice was like butterscotch: warm and smooth. I wanted to pinch myself; even her voice was perfect.

"I'm Tim," I said, holding out my hand.

"Hi, Tim, I'm Monique."

I apologized for sending Larry over. "That wasn't cool," I said.

"No it wasn't," she said. Then she smiled. "But you're forgiven."

We stood out in front of the hotel talking for a few minutes. Then I cut to the chase.

"Are you seeing anyone?" I asked.

"Not right now," she said. "Why?"

"I'd like to take you out," I said. "Tonight."

"No, thank you," she said. "I already have plans tonight."

I wouldn't be put off. "Could I at least call you?"

"Sure."

We exchanged numbers and I went back to my friends.

"When are you going out with her?" Magoo asked.

"I don't know," I said. "But take a good look. That's my wife."

When I returned to the States, Monique and I talked quite a bit on the phone. I was splitting my time between Virginia and Miami. She was living in Atlanta. I kept asking her to let me fly her to Miami for a visit, but she kept resisting. I respected that. But I really wanted to see her. So I kept calling.

Then disaster struck and all of a sudden, I wasn't thinking about relationships at all.

# 16

# A FACE I CAN'T FORGET

August 25, 2001. It started out like any other morning. I woke up and reached for the remote. I turned on the television and flipped through the channels absentmindedly. I was about to switch to the next channel when I heard her name. Aaliyah. I paused. On-screen, there was an aerial view of a plane, its nose smashed and fragmented in a wooded area. Underneath the shot was a caption: *Singer Aaliyah dies in a plane crash in Bahamas.*

I dropped the remote. I'm not sure what I hoped to accomplish by standing, but I made the attempt. My knees buckled underneath me and I fell to the floor sobbing. Not Baby Girl. Couldn't be.

I was still lying on the floor, paralyzed with shock, anger and sadness, when Missy called. She was in Jamaica for a show and her phone was blowing up.

"It's a mistake, right, Tim?" she asked plaintively.

I didn't want to say it was true. Maybe it wasn't true. But

something inside of me couldn't pretend. I felt the loss of her presence on Earth the same way I could feel thirst or hunger.

So I talked around it to Missy. I said, "She was only twenty-two, Missy."

"Tim, it's not real," Missy said. "People are saying we were on that plane. It's all rumors and conjecture. This is not the time for gossip and bullshit. I'm not trying to hear it."

I took a deep breath. "Missy, please listen to me. Baby Girl . . . Baby Girl is gone. She died in that plane crash. Turn on the news. It's everywhere."

There was silence but I could tell she was following my instructions. Walking into a room with a TV. Turning on the news. Then, after what seemed like forever, Missy started screaming. She was moaning, shrieking and screaming so loud that I was afraid she might have a heart attack or worse.

When she was done crying, I spoke to the team that was on the ground with Missy. And I prayed. Missy was going to have to get on a plane and come home. I needed her flight to travel safely, with God's mercy. I couldn't lose my whole family in one fell swoop.

I lay on the floor and tried to wrap myself in memories of the good times: the time she, Missy and I all dressed up in the same outfit for an awards show. All the videos we did together. The studio sessions where we had impromptu dance parties and laughing fits about nothing at all. Laughing so hard we could barely get any work done. I thought about the dinners out when we celebrated every number-one record. If we'd known our time together was destined to be short, I don't think we'd have done it any differently. No need for us to try again. We made music. We made each

other happy. The three of us—Aaliyah, Missy and I—were like kids in a musical relay race; we passed the baton back and forth and together we went further and faster than any of us knew we could go.

**AALIYAH'S SELF-TITLED THIRD** album had been released in mid-July, just a month before she died. It debuted at number two on the *Billboard* 200 and Hot R & B/Hip-Hop and quickly went to gold. When she died, stores couldn't keep the album on shelves. After her death, she was nominated for a Grammy for best R & B album and *Rolling Stone* named it the best R & B album of the year. All of the praise was more bitter than sweet. A lot of love went into that record, and over two million people in the US and more than thirteen million people worldwide received that love, took it home and made it part of the soundscape of their lives. I'd watched Aaliyah grow up making that record, seen her make strides from song to song. I wanted her to be there to feel all of that love. I wanted to tell her, face-to-face, how proud I was of her. I wanted her to be around.

My arm, the one that still had a bullet lodged inside, started hurting again. The pain was always on and off over the years, but after her death, it was a constant ache. It was as if my arm carried the pain for my heart.

I eat when I'm stressed, and I started consuming gluttonous amounts of food. Whenever I passed a mirror, I had to look away, because while I'd never been thin, my body was expanding in ways that I'd never known. It seemed like my every waking moment consisted solely of one of three

activities: eating, drinking, or crying. My mother kept urging me to go to church, to turn to God, who had carried me so far and through so much. They say there's a reason for everything, but Aaliyah's death made me question my faith in ways that frightened me. I felt like God had forsaken me. I feared that God wasn't real, that He was a construct I had clung to because of the lessons of my childhood rather than something that was living and real. Because there was no reason why Aaliyah should have died in such a senseless accident. There was no greater good, no lesson learned. Just heartache and pain for her fans, and for the friends and family of everyone who had been on that plane. So I didn't open my Bible. I no longer prayed as soon as I opened my eyes. Instead I drank, as early as seemed socially acceptable. Then I drank until the finish, to pass out, until I slipped into a stupor and I could forget the tragedy that life had wrought.

Alone in my house, without a girlfriend or wife, I kept the shades drawn and banned all guests. I gave up on grooming myself. Long days went by without shaves or showers. It was a good day when I bothered to brush my teeth. What was the point? I had enough money in the bank to never have to go anywhere again. I no longer had to dive for scraps of leftover pizza or scrape a plate of discarded Chinese food. I didn't have to sing, or make beats, for my supper anymore.

It was *Groundhog Day*; every day was the same as the one that preceded it. Even as I ate and drank myself into forgetfulness, it was like watching the news again, seeing the airplane in pieces, all the wreckage.

My mother called and called. Most of the time I let it go to voice mail. I couldn't bear to have her hear me slurring

my words, couldn't let her talk to me in the state I was in. When I did pick up, my mother urged me to get back into the studio.

"Tim, if you want to be happy, you have to do the thing that makes you happy," she would say. "Make some music."

It was like she didn't get it. When God silenced Aaliyah's voice, he had silenced me too.

"I don't want to make music, Ma," I said.

Then she took a sterner tone. "Killing yourself won't bring her back, baby."

I didn't answer. Didn't want to say how often that very thought—killing myself—had crossed my mind.

"Tim, are you there?"

I grunted.

"This is your crossroads, my son," my mother said. "The Lord does not give us more than we can bear."

Was she kidding?

I had begun thinking about the car accident that had killed DeVante's girlfriend Dana. I had used the Bible, my faith in God, to mourn that loss and put it to bed. I still thought of her every winter, when the ground was covered with snow and I remembered how we had driven just a few yards when the car spun and spun, out of control. Her death was a terrible loss, but I understood enough about the world to know that in the balance between nature and man, there were forces we could not control.

The loss of Aaliyah Dana Haughton was another matter entirely. I never called her Dana but as I read obit after obit, watched news reports and read the paper, her middle name echoed in death in ways that it had never echoed in life.

It hurt me to hear her referred to as a distant, past-tense person. I wanted to scream at every reporter, "She is not 'talented R & B singer Aaliyah Dana Houghton, who died tragically in a plane crash.' She is, she will always be, Baby Girl, my sister, my friend, the girl who called me 'Teddy Bear' because she knew that appealing to my soft side would keep me in the studio all night." Had I known how it would end, I would still choose to work with Baby Girl a million times over. It's like Nic Cage says in that old movie *Moonstruck*: "We aren't here to make things perfect . . . We are here to ruin ourselves and to break our hearts and to love the wrong people and *die*."

I didn't want to make beats. Couldn't really. I would go into my home studio and sit; it felt like my ears didn't work. The music of daily life hid itself from me. Footsteps were just footsteps and running water was simply running water.

There were still artists on my new label, Beat Club, that I had to think about. Jimmy Iovine at Interscope Records had so graciously offered me the chance to sign my own artists and produce my own records with all the creative freedom that I could imagine.

I had, in quick succession, signed three acts who I believed in. There was Bubba Sparxxx, a rapper with a country twang from Georgia. Bubba was white, and even though hip-hop had been a largely African-American terrain, I thought that Bubba had the chops to fit in as more than a novelty act.

Then there was Ms. Jade, a female rapper from Philadelphia who was very talented. She had a tight flow and I really believed in her lyrical expertise.

The third artist was a soulful singer from a small town

in Arkansas named Kiley Dean. Her parents had moved to Orlando and she had already begun making a name for herself with high-profile singing gigs, like singing backup for Britney Spears on her world tour. Kiley's voice was powerful and soulful and I had very big plans for her.

Most of the studio work on those albums was done. Bubba's album was set to come out. Jade's was on the horizon. Kiley Dean's album was done and our team was preparing to release her first single. For the artists on my label, I had a responsibility to put 100 percent into their projects. I could have banged out some new tracks for them or tightened up some of the songs they were preparing to release. But now I would sit at my mixing board and not be able to come up with anything new. Or I would listen to some of the Aaliyah records we'd made that didn't make the album. All the goofy Super Friends tracks we had made for our own amusement. Every single song, no matter how silly, left me heaving with tears. It couldn't be true, but it was true. Baby Girl was gone. Damn.

The phone stopped ringing as much, mostly because I rarely answered and never called anyone back. I didn't listen to the radio much. I was happy for my friend and brother Pharrell. He and Chad were producing powerhouses and I loved the work they did on NSYNC's "Girlfriend," Usher's "U Don't Have to Call" and Fabolous's "Young'n (Holla Back)." Yet sometimes when I listened to his songs, it hurt. I wondered if I would ever produce music that was so pure and joyful again.

Missy kept urging me to get back in the studio, pour the pain onto a track and make some music that Aaliyah would be proud of.

"You working on anything?" she asked.

"Yeah, here and there," I'd say, lying. As soon as we were off the phone, it was back to my other companion: A bottle. Any bottle. A plate of food. Any food.

**A FEW MONTHS** after Aaliyah's death, Jimmy Iovine called me in for a meeting. I cleaned myself up, got on a plane and went. I had hoped that my label could survive without me, that somehow the industry would give me time to mourn and heal, but that's not the way it works.

At first, I thought my instincts had been off. Jimmy seemed happy to see me and as we exchanged hellos, I had this fleeting thought that I had just been paranoid. I had made the record company millions; they would understand that I'd hit a rough spot. But the moment I sat down, something in the room shifted. My gut had been right. Things weren't good.

"Tim," Jimmy began. "I don't know anyone who works harder than you. And I know you believe in your artists, but Beat Club is just not working."

Even though I was going through some things, I didn't want my heartache to hurt my artists, and I told him so. "Look, I know I've dropped the ball," I said. "We just need to formulate a plan and strike harder the next time."

Jimmy shook his head. "I can't afford a next time, Tim. We have to dissolve Beat Club now. I'm sorry, believe me I am. I know how much it means to you, but this is a business and we're losing money on the imprint."

"And nothing I've done in the past can convince you to give us a little more time?" I asked.

"Afraid not, Tim," he said.

I rose from my seat, shook his hand and walked out. Now I had some very difficult phone calls to make. It was just weeks after September 11 and it was a hard time to push party music. Bubba's album, *Dark Days, Bright Nights*, was released just three weeks after the terrorist attacks. Still, it peaked at number three and eventually achieved gold status. Five hundred thousand copies sold was not nothing, but that's how punishing this business is.

Jade's album was released a year later. November 2002. We believed in the project and I did all but two of the tracks. I was so happy to be able to bring in Pharrell's production team, the Neptunes, to do work on the album as well. We lined up guest spots from Missy, Nelly Furtado and Jay Z. Still, the people were just not feeling it. Jade was—is—so talented. But I believe she was a victim of the sexism in the music industry. It's like there's some unspoken rule that there can only be one big female rapper in the game at a time. It was like the Lauryn Hill line: *Two emcees can't occupy the same space at the same time. It's against the law of physics.* This is how it was for Jade. Try as hard as we did, it just wasn't her turn.

Kiley Dean's album was shelved completely. Interscope didn't feel like we had a strong enough first single and the reception of the songs we put out underground wasn't strong enough. Every rejection felt like a personal failing. I was such a long way from the Da Bassment days and yet I felt like somehow I'd gone crashing back to those times when I was

scrambling for food and scrambling even harder to catch a break. As the founder of Beat Club Records, I had a responsibility to these artists. Their hopes, dreams and careers were dependent on what I could make happen for them. I had no beef with Jimmy Iovine. He was an executive. He had a responsibility to make sure that the profit margins were strong, or it was his ass on the line with Universal Records. It was like Bob Dylan sang:

> You might be a rock 'n' roll addict prancing on the stage
> You might have drugs at your command, women in a cage
> You may be a businessman or some high-degree thief
> They may call you Doctor or they may call you Chief
> But you're gonna have to serve somebody, yes indeed
> You're gonna have to serve somebody
> Well, it may be the devil or it may be the Lord
> But you're gonna have to serve somebody

I wasn't feeling confident or healthy. But after Beat Club folded, I knew I couldn't afford to sit around the house feeling sorry for myself. So I went back to work. I dragged myself into the studio each day, but I couldn't make the magic happen. I didn't like any of the beats I was making. I felt like a musician who'd forgotten how to play the instrument that had been his life. Even my mixing board, which had once been an extension of my own two hands, started to look weird to me. Sometimes, I'd look down at the board and I felt like I was on a bad trip: the lights and the knobs looked like cartoony, sad faces.

I still talked to Monique, the beautiful girl I'd met in

Jamaica. I don't know if it was the circumstances of my life, but I think I was at a point where everything was so real and so raw that she could see who I was, Timothy, the man, as opposed to Timbaland, the artist. She finally agreed to come see me in Miami. I was so excited, but I think I was also a little scared. Because when her flight arrived from Atlanta, I was shopping for sneakers at the local mall. Instead of going to pick her up at the airport, I sent one of my boys to get her.

When I got back to the house, two hours after her flight had landed, my friend Larry was sitting alone in my house.

"Where is she?" I asked.

"She left," he said.

I was shocked.

"She sat right here, called the airline and booked her return flight back home. She said you must not have been serious about seeing her if you made her wait so long."

Believe it or not, I had the nerve to be mad. I'd paid for her flight. I'd planned a whole romantic weekend. I started sputtering and talking like I was some badass Don Juan who'd been stood up. Then I realized: I wasn't mad at her. I was mad at myself. Why did I assume that she was like other women that I'd fooled around with? Those women would have waited even longer to see me. They let me get away with anything because they thought that was the only way to get me to give them the things *they* wanted. Monique was different. She was her own woman. She made her own money. And she made it abundantly clear whenever we talked that she wanted my conversation and my company; anything else was just the icing on the cake. She once explained it by

saying, "I'm not the type of chick to eat frosting out of a jar. There's got to be the cake. I need the substance of something real." I should have reached out to her right away and apologized. But I was so embarrassed; I felt so exposed that instead I kept my distance. Picked up the phone a hundred times. And a hundred times, put it right back down again.

Luckily, work started to pick back up again and I had something to distract me. Jay Z called and said he was looking for beats for *The Black Album,* his farewell CD. I *knew* I had to get a track placed on that album. From the beginning, I knew that project would go down not just as a cornerstone of hip-hop, but as an iconic moment in pop music.

On the day he came by the studio to hear the beats, I was prepared. I pulled on some clothes—not really caring how I looked—and grabbed a gallon jug of juice from the studio fridge. I could tell that Jay was surprised at how much my appearance had changed. I had always been husky, but my weight ballooned after Aaliyah's death. And at that point, I didn't really care.

After we shook hands and said our hellos, Jay and I got right down to business.

"You don't have any choice but to like this beat, Jay," I said. I bobbed my head furiously as I played him track after track. He sat next to me and listened. Just knowing he was coming had inspired me in a way that I hadn't felt in a long time. But nothing I played really grabbed him. An artist like Jay Z knows exactly what he wants and how to get it. If he's not feeling your beats, you're out of luck. For someone like him, it's not about friendship and it's not even about what'll sell. He's got to feel it in his soul or he's not buying.

I played him five tracks in all and then he said, "You got anything with a little bit of bounce to it?"

He smiled, as if he was challenging me.

My other tracks were hot; I knew that. But he wanted something that *only* he could flow over. Something more complex. Luckily, I had a track that I had been holding back for precisely this purpose.

"Cue it up," I told the engineer. Then I rolled my eyes at Jay. "Do I have something with a *little* bounce? You better sit back from the board."

Then I cranked the beats for what would become "Dirt Off Your Shoulder." Jay just about lost his mind. He started bouncing around the studio, nodding his head so hard I thought he might break his neck. When I crafted that beat, I was trying to capture the energy of a high school marching band, all outfitted with electronic instruments. The bass was unrelenting on that song, and I wanted to capture some of what I thought made Jay so special: from the Marcy projects to the highest echelons of American culture, he had been relentless in his creativity.

Still, Jay didn't come out and say he was choosing my song for his album. He liked to play things close to his vest. So all I could do was thank him for his time and wish him the best.

Missy was ready to start working on her next album. Ironically, she called the album *This Is Not a Test!* Because the truth is that album *was* a test of our friendship. I love that girl more than I love my life, but Missy drove me crazy making that album. *Crazy.* We had a million little arguments and our longtime engineer, Jimmy Douglass—the

same guy who'd helped me save my masters from DeVante's basement when I was just a scrub producer trying to get put on—had to mediate more than a few times.

It started almost as soon as we began recording. As always, I had lots of tracks cued up for her. Usually, she would hear a beat, find a melody and write lyrics in a day, at the most. We were so in sync that we'd done her debut album, *Supa Dupa Fly*, in two weeks flat. This time around, Missy was not feeling me.

"Eh, I'm not in love with that track," she said when I played the first one I'd composed specially for her.

She didn't like tracks two through ten either. I was surprised but not daunted. I was back in the swing of things and I had beats for days.

"Okay," I said. "What about this one? It's so Missy."

I played the next track and waited for her response.

"Eh," she said.

I looked at her. "Did you just say 'eh' again?"

She looked at me, disappointed. "I'm sorry, Tim. I'm just not feeling that one."

I took a deep breath. "Missy," I said, "I got people fighting to buy that track."

She shrugged. "So sell it. Let me hear something else . . ."

Anybody else, I would've cut the session short and wished them good luck with their project while I showed them the door. But this was Missy. We didn't just have history. She was my history. So I kept at it.

Looking back, I think we weren't at the best place to work together. The fact that Missy couldn't find a beat she liked from my whole collection was a sign of that. We were both

still mourning Aaliyah and I think we were trying to figure out how to go back to being just the two of us when we had created something so unique as a trio.

Missy ran her hands over the keyboard randomly.

"I like the way that sounded," she said with a smile. "Let's make a beat based on that."

I just glared at her.

"Oh come on," she said. "Lighten up. Play me some more beats."

I played another ten tracks. She didn't like any of them.

"Maybe we should try again tomorrow," I finally said.

"Okay, I'll be back!" Missy said cheerily. Either she didn't notice how mad I was or she was pretending not to notice.

The next day, I made up a reason why we couldn't meet at the studio. The day after that, I told Missy I had a session booked with another artist. I avoided her for a whole week, because like Erykah Badu said, *I'm an artist. And I'm sensitive about my shit.* Nobody in the world knew me like Missy Elliott. But when she turned her nose up at my beats, I was hurt.

"When's Missy coming back to the studio?" Jimmy asked me that weekend.

"Don't know, don't care," I said.

Jimmy is the one who showed me that I needed to squash it. "Tim, you're a perfectionist," he said. "We know that she's a perfectionist too. That's what makes you great together. Y'all love each other too much to play little games like this. Get over it and get back to work."

Jimmy was right. I called Missy and we got to work right away. I realized that as Missy grew as an artist, she wanted

to play a bigger role in the producing end. She coproduced two of my favorite tracks on that album: "Wake Up," which featured a rhyme from Jay Z, and "Keep It Movin'," a song that we brought reggae superstar Elephant Man in on. By the time Missy and I finished her album, we were both happy with the way her body of work was growing. That the album went platinum was just the icing on the cake.

# 17

# TRY AGAIN

In the summer of 2003, I hit hard with "Dirt Off Your Shoulder," the track I produced for Jay Z. It was picked as the second single and charted well. Everyone was walking around pantomiming the act of brushing imaginary dirt off their shoulders after the video dropped. And a few years later, when Barack Obama was in the lowest days of his historic bid for the presidency, he responded to the petty campaign politics not with words, but by symbolically brushing dirt off of his shoulders. When reporters asked his aides if Obama was specifically referencing our song, the campaign replied and said, "Well, he does have some Jay Z on his iPod." Epic moment!

I was happy and honored to be part of another hit record for Jay, but I didn't take a second of it for granted. The song could just as easily have not been chosen to be on the album. It didn't have to be a single. It didn't have to be a hit song. I had been blessed all around and I was present enough and grounded enough to know it.

Maybe because I had my swagger on from the Jay song, I'd summoned the courage to call Monique and apologize for the way I'd messed up when she came to Miami. She *still* wasn't trying to date me, but we talked on the phone for hours on end and little by little, we were becoming friends.

While working on a single is always fun, there's really nothing like working with an artist from start to finish on a project. When you do an album, as opposed to a single, it's like making a movie versus making a television commercial. As a producer, you're like a director. You have a vision and you can carry it through from start to finish. Which is why I was thrilled when I had the opportunity to be the lead producer on a project for Brandy's fourth album, *Afrodisiac*. She had been one of my favorite singers for years and years. I call her by the name of her hip-hop alter ego, Bran-Nu.

When she came into the studio I started by asking her, "What are you looking for this time around?"

A lot of the artists I work with want and need time to talk through their ideas. They might not be able to play an instrument or write music. But I talk to them about what's been going on in their lives, how they're feeling at the moment. As they talk, I start mentally making a stockpile of sounds—the same way that a painter might start mixing colors in a palette.

Brandy let me know she was ready for something new. She came in with the title *Afrodisiac*, and that play on words let me know she was freeing herself from her good-girl image. She wanted to take chances, embrace her sexuality and let the world get to know her as a fully formed woman. We began recording at the end of 2003 and I felt like I was get-

ting the best she had to offer on each and every track. Later, when Rihanna was making her debut, she cited *Afrodisiac* as a major influence. "Brandy's album *Afrodisiac* really helped to inspire [me] . . . because that album I listen to all day, all night. When I was in the studio that was the album that I listened to all the time . . . ," Rihanna told *Entertainment Weekly*. "I really admired that every song was a great song."

Nate Dogg, an artist who became known for his work with Snoop's Dogg Pound, approached me about producing some tracks for his upcoming album. I created three tracks and put Jade on two of them. Ms. Jade is still one of the hottest, dopest, most original female lyricists I know. And even though Beat Club had folded, I made sure to take care of her and keep her working.

Jade stepped into the booth and started to spit her lines:

> *Hustle for rings, give me the chains*
> *Oops my Betty ain't part of the game*
> *I got friends in the front*
> *Ho's in the back, Nate Dogg in the 'lac*
> *Timbaland on the track*
> *Bubba Sparxxx, Petey Pab and Sebast in the back*

Jade writes her own rhymes and she has a flow that is just sick. And when she's recording, she puts her whole body into her delivery.

Nate listened to the track and hit me up.

"Yo, your girl Jade is the truth," he said.

"I know," I said, smiling for the first time in what felt like forever.

"It wouldn't be hot without your beats," Nate said.

I thanked him and then he said, "Look, I know it's been tough for you and Missy since Baby Girl passed away."

I looked down and didn't say a word.

"But I really respect that y'all are still hustling. She would not have wanted you to be holed up in some dungeon, depressed and shit."

Sometimes in hip-hop, male artists can put up a wall. You talk about everything, but really you aren't saying anything. I appreciated the fact that Nate had reached out and really said something to me about our loss. He had soul. It wasn't just in his music. It was also in his heart.

The next track I worked on remains one of my all-time favorites. The artist was a girl from Harlem named Kelis. I'd known her for some time. I remembered years ago, when she was recording her first album with Pharrell, I came into the studio and heard someone screaming, "I hate you so much right now!" at the top of her lungs. There was something so artistic and just plain dope about it. The song she was working on would go on to be a major hit for her and Pharrell. It was just so different. The chorus was a woman literally screaming at her man. And her style of singing—deep and throaty—was such a departure from what was on the radio at the time.

I filed Kelis away as an artist that I hoped to work with in the future. I knew she was eccentric enough to get my beats and I loved her brash, in-your-face charm. I got my chance just a few weeks after finishing the Nate Dogg track with Ms. Jade. My song with Kelis was called "Running Mate" and it was a bass-heavy, electronica-influenced jam

about wanting someone who would always be by your side, who would hold you down and lift you up. Writing that song made me realize how much I was missing having a running mate. I started to feel social for the first time in months. My boys and I started going out after our studio sessions and I began to date again.

One night, I was getting ready for a date when my phone rang. "Hey, Tim, it's Monique," said the familiar sultry voice on the other end of the line.

"Hey, how are you?" I asked.

"I'm good," she said. "Just checking up on you. What are you up to?"

I smiled. "Actually, I'm getting ready for a date . . . You jealous?"

"Please," Monique laughed. "She's not me so it doesn't really matter."

I *loved* her confidence.

"You're right," I said. "She's no you."

"Have fun on your date. I'll talk to you soon," Monique said before hanging up.

My date was okay but the fact is that I was always thinking about Monique. But I was also always thinking about my career. I was happy to be making music again, but while my songs were going gold and platinum, I didn't have the runaway, chart-topping, genre-shaping success I'd had when Missy and I worked with Aaliyah. Like Nick Hornby wrote in his novel *A Long Way Down*, "Hard is trying to rebuild yourself, piece by piece, with no instruction book, and no clue as to where all the important bits are supposed to go."

# 18

# TRAINING DAYS

One day when I was in Atlanta, Monique and I met up for lunch. I was still dating other women since she wouldn't be with me. But our friendship was strong.

Over lunch, Monique said something to me that few others would. "You're not eating right, you're not sleeping well—this is not good for you."

"I know," I said, feeling self-conscious about my extra weight. "I'm gonna get a trainer. Right after I finish Missy's album."

She wouldn't be my girlfriend, but Monique always had my back.

In spring 2005, Missy and I had begun working on her sixth studio album. It would be called *The Cookbook*. It was an apt name because we were throwing all kinds of flavors into the pot that was her album and stirring it like gumbo. I ended up working on only two of Missy's songs. It was the first time that I hadn't produced the entire project. In the industry, the rumor was that we'd

had a falling-out. But there was no such thing. We'd been working together since high school! Missy had to spread her wings at some point. She needed to see what other producers could bring to the table in order to keep growing as an artist. Missy is my sister. I'll always do as much as I can for her. I'm always happy to do even just a little if a little is all that she needs.

Since my time had freed up, I joined a gym in Miami, where I was living full-time, and began working out with a trainer named Phillip. True talk—Phillip damn near killed me. I was never athletic and going into the gym was *not* my idea of fun. At the time, I was almost three hundred and fifty pounds. Who wants to be a four-hundred-pound black man? I would take off my shirt and my breasts were bigger than a woman's. I got very depressed. It wasn't good for me. It wasn't good for my music. So I agreed to start working out. Baby steps.

"Tim, you have to give me three more reps," Phillip barked.

"Damn that," I said, rolling my eyes. "I'm done."

"You can do it! Push it out. Make it happen."

But that's the thing; I don't speak in riddles or code. When I say that I'm done, I mean it.

"I'm going back to the studio," I told Phillip.

He shook his head. "We need to do some cardio and a little more—"

I wasn't having it. "Thank a lot, Phillip," I said. "See you on the flip side."

I knew Phillip was disappointed in me. But my attitude was, *Oh well*. The studio was calling and I always answered.

Working out just wasn't a priority for me. I had gained an additional fifty pounds since I'd started working in the studio again. I was snoring loudly at night and my doctor said it was probably sleep apnea—when you stop breathing temporarily—which was likely caused by weight gain. All of the doctor's concern and warnings went in one ear and out the other. The only thing I listened to was my ASR-10. Everything else? I pressed mute on my mental recorder and the sound went blank.

A few months later, I was working with LL Cool J on his comeback record *The DEFinition* when I finally got the message that if I didn't respect the instrument that was my body, I would never truly be the greatest in the music biz.

"You've been through a dark time," LL said. "But it doesn't have to stay that way."

I didn't answer.

"*You* are in control of how people view you and how they respond to your energy," he continued. "Are you working on you?"

"You mean my music?"

"No, that's gonna happen for you either way," he said. "Are you taking care of *you*? Eating right? Working out?"

I thought about the four or five sessions I'd done with Phillip.

"Get your health right," LL said. "Everything else will fall in place."

I knew that the studio lifestyle was catching up with me. In the studio, there's no time or means to cook a healthy meal. So there was a lot of ordering out and not a lot of healthy options. My weight had continued to be an issue

and it was beginning to slow me down. I had to make a change—a serious one. I was at 331 pounds.

They say when the student is ready, the teacher will appear. When I met trainer Jose Garcia through a mutual friend, I was more than ready.

"Are you starting to see and feel the effects of the extra weight?" Jose asked.

I had. I didn't want to tell him how much I weighed or how dire the doctor's warnings had become, but I was ready to make a change, so I figured there was no holding back. I told him that I'd been diagnosed with diabetes, high blood pressure and high cholesterol.

Jose just nodded. "Of course, you know all of this can be rectified with weight loss, right?"

"Yeah, I know," I said.

"So let's get to work."

Honestly, I was skeptical that I could really change my body all that much. I'd been a chubby kid and a husky teenager. I'd never been truly thin or fit. "How do I know you'll be any different than other trainers I've worked with?" I asked.

"Give me six weeks," Jose said, "and you'll see why I'm different. Six weeks of your life—with your full cooperation and dedication to the plan. You'll see what I can do. More importantly, you will see what *you* can do."

I lost fifty pounds in six weeks.

It was insane. I stopped snoring so loudly that I would wake myself up. My blood pressure went down and my cholesterol levels did too.

In six months, I was down more than one hundred

pounds. With Jose's help, I got myself from 331 pounds to 222, the lowest I had been in my adult life. Once I got the weight down, I became even more ambitious in my goals.

"I don't want to be just lighter in weight," I told Jose. "I want to be cut up. I want my muscles defined."

"We can make that happen, Tim," Jose said confidently.

I was blessed to have Jose in my life. He had trained professional football players and he knew how to get results. I had two hour-long training sessions a day: circuit training and cardiovascular to increase my heart and lung efficiency.

His wife and business partner, Leslie, put me on an even stricter diet after I lost my first hundred pounds. The diet was harder for me than the workouts. There was no sodium and it was high protein: nothing but chicken, tilapia, ground turkey and egg whites. And of course, tons of vegetables and healthy fats from items like almonds and flaxseeds.

I remember being in the studio with Keri Hilson and I had my little plastic case of food: a little piece of chicken, a little bit of rice, a whole lot of greens. I've seen kids' lunches that were bigger than what I was allowed to eat. Keri looked at my meal and said, "You're going to eat just that?" I told her, "Yes, I am." I had seen that what Jose and Leslie had done for me was working and I was starting to discover a new high—the high of losing weight and feeling good about myself.

My body was *sick*. I was so proud of what I was able to achieve. I had a *six-pack*. I didn't even know I had those muscles under there. I felt like a new man and I had done it using my own willpower. I could have gotten Lap-Band surgery or tried other surgical means. But I didn't. I sweated

that weight off. I worked that weight off. And it made me feel like I could do anything.

The only downside to working out so intensely was that the pain in my arm from when I'd been shot returned. It was almost more than I could take. I started taking pain pills to get through my gym sessions and the pills became a problem a few years down the road. But for the moment, I was looking good and feeling good. Music even sounded different to me. The sounds were more vibrant and alive. I felt like I could record masterpieces again. I realized that LL had been right. The outside controls the inside.

Around this time my friend Polow happened to be hanging out with Jimmy Iovine in Los Angeles.

"You need to see Timbaland," Polow told Jimmy. "And you need to hear what he's been working on. It's good. Better than good."

"Really? I love Tim," Jimmy said. "Even though the Beat Club didn't work out, I still believe in his talent and I'd love to hear what he's working on. Can he send it to me?"

Polow shook his head. "Nah, Jimmy. You need to *see* Tim. In person."

"Why?"

"Because you just do."

"Okay, I will," said Jimmy.

A few weeks later, I flew out to Los Angeles to see Jimmy. His mouth literally dropped when he saw me. I knew that I looked like a whole new person. I felt like I exuded a confidence and strength I'd just never had before.

"Timothy!" Jimmy said. "You look amazing!"

I played some tracks for him and I thought his head was

going to snap off, he was bobbing to the beat so fast.

He stood up quickly and shook my hand. "We've got work to do. I have a few artists I need you to work with . . ."

I always believed what I felt like and looked like on the outside didn't affect my music. But after I dropped the weight, I realized how wrong I was. Your health directly affects your entire lifestyle. From your personal relationships to your creativity. After I improved my health, I decided to improve my love life as well. I finally stopped playing around and decided to get my woman.

"Monique, I need you to listen to me," I said on the phone.

"I'm listening," she said.

"We've both been through a lot of relationships . . ."

"Yes, we have."

"I've known you for four years and I've liked you since the moment we met," I said.

"Same for me."

"Let's do this, then," I said insistently. "Put your guard down. Give me the chance to prove to you that I can be the man you need me to be."

Monique was silent for so long, I wondered if she'd hung up the phone.

"You there?" I asked.

"I'm here," she said.

"And?"

"And I'm scared."

"So am I," I said, revealing myself in ways that I never would have before. "But sometimes you have to do things that are scary in order to progress."

Monique agreed to meet me in Miami and this time, I

didn't waste time shopping at the mall. I also didn't send any of my boys to go and get her. I went to the florist and got a giant bouquet of flowers. I told the florist to give me the rarest, most lavish flowers she could find. As she wrapped them up, she said, "You know what we call these? Hothouse flowers."

I thought there'd been a group with that name, but I never knew what the term meant.

She explained that hothouse flowers are so delicate that they can only be grown under special care. They're grown in a high-temperature greenhouse called a hothouse.

"Perfect," I said, taking the arrangement from her and giving her an extra-large tip. "These couldn't be more perfect."

I hadn't seen Monique in months, so I was excited for her to see my new physique. I half-expected her to think that I hadn't shown up. I looked that different.

But as I stood at baggage claim with the flowers and a little sign that said, "The Future Mrs. Mosley," she walked right up to me with a big smile on her face.

"I like the flowers," she said, kissing me on the cheek when I handed them to her.

"And the sign?"

She raised an eyebrow. "You're rushing things a little bit, don't you think?"

I shrugged. "Maybe."

Then I pointed to myself. "And this?"

She played coy. "What about that?"

I said, "I lost a little weight."

"So you did."

"I didn't think you'd recognize me."

"Tim, this is how you always look to me when we talk on the phone," she said, turning serious.

"You mean you like to fantasize about me being all cut, with a six-pack?"

She shook her head. "No, I like to fantasize about you being healthy and happy. And now it's coming true."

We walked to my car and as we drove back to my house, I gestured to the bouquet, which was sitting in the backseat. The car smelled of flowers, like it was a beautiful tropical garden on a sunny day.

"You know what they call those flowers?" I asked.

She turned her head. "I don't. I see some orchids and plumeria, but I don't know what else is in there."

I smiled. "Those there are some hothead flowers."

She gave me the side eye. "What do you mean?"

"The florist said they were hothead flowers."

She sighed, "Tim, I think you mean hothouse flowers."

I smiled. "So that's what you think I mean?"

She gave me a playful punch on the arm.

It was all coming together. I'd have to prove it to her. I'd have to show more commitment, more love, more than I'd ever wanted or been able to show a woman, but I was going to marry Monique. We were made for each other. I was convinced of it.

# 19

# MY BROTHER FROM ANOTHER MOTHER

From the moment Jimmy Iovine hooked me up with Justin Timberlake, we clicked. He's from Tennessee, I'm from Virginia, and immediately we bonded over being from the South. It reminded me of the immediate connection I'd felt with Missy and, later, Aaliyah. With some people, you just know the bond is there immediately. That's the way it was with Justin. He walked into the studio like a true professional—on time, no drama, no entourage, ready to work. Somehow, in between cranking out songs together, we ended up talking. In addition to both being from the South, we also have similar soulful tastes in music. I ended up having a lot more in common with him than I ever thought I would. I mean, he was a pop idol from a super-successful pop band, NSYNC. He was a blond white boy who had legions of fans in the MTV *TRL* world. We had lots in common, but on the surface, it seemed

like we had nothing in common. I hadn't had much experience working outside the R & B and hip-hop world, and working with Justin Timberlake was a true departure.

That said, I always *want* to work with artists outside of my comfort zone. My intention is to do it all, from classical and opera to funk, pop, rock and hip-hop. Yet there were whispers from within the industry: *Timbaland sold out. Timbaland thinks he's too good for hip-hop.* It made no sense to me then and makes no sense to me now. I'm all about growth. I'm all about doing what makes you happy. When Jimmy Iovine gave me the opportunity to work with Justin, what was I supposed to say? *No thanks? I only work with hip-hop and R & B artists?* That's crazy.

"Cry Me a River" was born out of the end of Justin's relationship with Britney Spears. There had been some talk that she'd been saying some slick things about him onstage at her shows and he wanted to respond. He walked into the studio and I could see that he was visibly angry. But he wanted to work. I was beatboxing the song at first and Justin said, "It sounded like a march to me. It matched the way I felt."

Justin began singing, just whatever was in his heart: "*You were my sun . . . You were my earth . . .*" It was one of those synergistic, serendipitous moments.

The track begins with the sound of rain, but for me it was a totally different rain than what you hear in "Supa Dupa Fly." I added a male voice that sounded like a monk reciting a Gregorian chant—for me, it added that element of timelessness, because what is more ancient and universal than a broken heart? The beat drops and then it's just Justin's voice finding its way through all the layers of strings and percussion.

As we continued to work on the song, we added elements: the sound of knuckles being cracked, a man's voice shushing someone and other pieces that gave it an almost soundtrack-like field. Like Jay Z, Justin wrote the lyrics entirely in his head. He came into the studio, listened to my track and then laid his lyrics down in practically one take. I remember thinking, *This boy is the* truth. That's when I knew we had magic, and honestly I hadn't had *that* kind of magic in the studio since working with Aaliyah.

"Cry Me a River" ended up being a monster hit for Justin, charting at number one and winning him a Grammy. The album *Justified* ended up triple platinum in the US with over seven million in sales nationwide. It was on and popping. We spent three years touring with that album. We all enjoyed that success, but the money that we made and the awards that we won paled in comparison to the fun we had in the studio. Working with Justin on his debut solo album was the beginning of a collaborative relationship that I believe will last as long as I'm alive and making music.

In 2005, Jimmy Iovine also introduced me to another artist who would broaden my musical landscape: Nelly Furtado.

"I just want to jump into the deep end of the pool," Nelly said one day. She shot up and put her arms together and mimicked the actions of a swimmer springing off a diving board. "I want to express my womanhood, my sexuality and my God-given talent to sing."

I nodded. "So what kind of album are we making? Hip-hop, pop, R & B, rock?"

Nelly looked up at me and winked. "I guess I just want to be promiscuous—musically, that is. I want to cheat on every

kind of music with every other kind. Does that make any sense whatsoever?"

It made every kind of sense to me. It's what I'd been reaching for my whole career.

Over the next few weeks, I made a steady stream of beats for Nelly. The first track I played for her would end up becoming "Maneater."

"I love the surreal theatrical elements of eighties music," she said, snapping her fingers and dancing to the beat.

Making that album with Nelly was like taking a time-warp trip back to the eighties. We both loved the modern, spooky pop sounds of groups like Eurythmics. To that, we added our own sounds—no track was a pristine three-minute pop song. If you listen closely to the whole *Promiscuous* album, you'll hear coughing, laughing, distorted bass lines. I purposely didn't mix any of the tracks with a fancy mixer because Nelly liked the music to sound more raw and unpolished. We constantly felt like we were re-creating, in our little studio, the frenetic after-midnight dance parties at the Paradise Garage in New York where Diana Ross and Madonna partied side by side with Willie Colón and Nile Rodgers.

Each day, before I got to work, I hit the gym. Working out was my way of staying on track. My music sounded better when I worked out and I wasn't taking any chances on losing that mojo.

Monique was proud of me too. She traveled with me, and I was trying to convince her to quit her job and come work with me. She was very supportive of my weight loss—even though I knew she had loved me at my heaviest.

**FOR A WHILE,** Justin was doing more acting than singing. He did all kinds of movies, from crime dramas like Nick Cassavetes's *Alpha Dog* to big-budget animation flicks like *Shrek* to indie films like *Black Snake Moan*. But in the fall of 2006, it was time for us to go back to the studio. When Justin came down to my studio in Virginia Beach to work on his follow up to *Justified*, it had been a while. For the first few weeks, we did nothing. Absolutely nothing. I made beats here and there. Nothing thrilled Justin. Nothing thrilled me.

That's the kind of relationship we had. There was no pretending.

Justin grew frustrated. "I've been singing and writing songs all my life. Why isn't this working for me? I feel like we have no direction whatsoever."

Obsessing over making hits is the biggest hurdle to anything I've ever attempted to do in the studio. When tensions run high and the pressure is on, I have to remind myself that it's not my job as a producer to give you a hit song. It's my job to give you a hot beat, an amazing score. My failures are as vital to my process as my successes. Not everything I've done has worked, but I know by now that I'll never get the big hits if I don't give myself the room to be bold enough to try something that might fail. It's like mining for gold or diamonds. You've got to do the work to extract the goods: dig through the mud and sift through the muck. Getting your hands dirty is the best part. You've got to love the work as much as you love what the work brings. I needed to get Justin to reconnect with the joy of sifting through the catalog of

sound and the joy you feel when a beat, a melody, grabs you by the heart and won't let you go.

"Let me ask you this," I said gently. "What kind of sound are you looking for?"

Justin turned on the radio in the corner of my studio and started turning the dial to various R & B and pop songs. "Not this," he said when one song came on. "And not this," he said when a formulaic R & B song came on. "And definitely not this," he said as a fluffy bubblegum pop song blared through the speakers. He switched the radio off and stared at me.

All I could do was laugh. He was so serious and he didn't need to be. We were going to make this happen.

"Okay, so now I know what you don't want. Let's try to focus on what you *do* want."

We were working a lot with Nate "Danja" Hills on the album and he became like a brother to both me and Justin during this time. It was Danja, who was so gifted at writing opening chords, who finally led us to a productive jumping-off point. "Justin," Danja said, "you've been acting and making movies and doing everything *but* singing. On top of all that, you feel like you need to top *Justified*. We all feel that pressure. But don't y'all know this is a good thing?"

Justin raised his eyebrows in disbelief.

"We're not aiming for anything," Danja said. "Let's do something that's ten times better than *Justified* and call it a day. Justin, what's your favorite song from that album?"

Justin answered without hesitation. "'Cry Me a River,' all day, every day."

"So let's start there," Danja said, beginning to play the

opening chords on his keyboard. "Don't worry, we're not going to copy it. We're going to make it better."

I started fooling around and freestyling with some of the sounds from "Cry Me a River." Danja added a guitar riff out of nowhere. As soon as I heard that riff, I knew we were onto something.

When you're producing with someone else, you have to be open to what they're doing. You can't be so self-centered that you're only listening to the sounds you're making. You have to be in harmony with everyone in the studio and bring them in. If that means you end up with twenty people who have writing or producing credits on your song, then so be it.

Justin was excited by what he heard. "Let me hear that riff again, Danja," he said. "Tim, rock that beat you just did."

First came a melody, a plaintive ballad with lots of strings like "Cry Me a River." But this was different: darker, edgier. Justin stood next to me at the boards and added drums to the sound.

"I'm ready to go into the booth," he said, a serious look on his face.

"What are you talking about?" I asked. "You didn't even write anything yet!"

Justin smiled and signaled the engineer. "I'm ready to go into the booth. Can you pull up what we've done already?"

In the booth, he smiled and spoke directly into the mic: "I have a friend who's going through some things with his girl right now. This song is for him."

Danja's guitar solo came first. Then came my strings and Justin's drum pattern. Justin stood silently, nodding his head with his eyes closed. Then he began to sing:

*Hey girl, is he everything you wanted in a man?*
*You know I gave you the world*
*You had me in the palm of your hand.*

It was just like old times. We were all doing what we loved to do. And, finally, after a few weeks of sheer nothingness, we had our groove back.

We built the next track on a foundation of synthesizer chords, beatboxing, percussion and staccato sounds. None of us knew where we were going with it, we just liked the way it sounded.

"This is a love song—but a sexy one," Justin said, bopping his head to the beat. "It's about love. Not just any old love, but the way I approach it. The way I see it. It's about *my love*." He started singing the words—*my love / my love / my love*—over and over and I began to flow the beats around his voice.

We let the beat ride out for a while, letting the listener really adjust to the staccato rhythms and the synthesized horns. There was even a gleeful "hee-hee-hee" sound that Justin made because he was so happy with the beats. You can hear it on the song if you listen closely.

"Are you ready to get in the booth and knock something out?"

"I think so," Justin said. He looked nervous but excited.

Using his flawless falsetto, he started to sing:

*If I wrote you a symphony*
*Just to say how much you mean to me*
*What would you do?*
*If I told you you were beautiful*

*Would you date me on the regular?*
*Tell me would you?*

Within minutes, Justin had another banger. The ballad was heavy hitting but sexy, plaintive but seductive. After we got T.I. to put a verse on it, we were all satisfied with what we'd put together—though I'm tempted to say "somewhat satisfied" because Justin and I were always inclined to just keep pushing it further.

During the time we were making his second solo album, Justin was listening to a lot of INXS and David Bowie. He threw himself into the booth as soon as he could imagine even a snippet of a song because he wanted the tracks to have the raw and unrehearsed vibe that those bands are about.

Once we had a few strong songs under our belt, I asked Justin, "So what do you think this album is about?"

He smiled. "In one word? Sex."

We conceived of the album as two halves of a whole. The first half, which we called *FutureSex,* was more aggressive and more suggestive. Some of the tracks on that side were "Love Stoned" and "Damn Girl." The second half, which we started calling *LoveSounds,* had a sweeter, more romantic vibe—all of the things you feel before and after you've had the best sex of your life.

While sex was the motif, we took some detours. Justin recorded a song called "Losing My Way" that was inspired by a documentary on meth addicts that we'd all seen after a late night in the studio. "(Another Song) All Over Again" was a tribute to the soul singer Donny Hathaway, one of Justin's idols—and mine too. The Donny Hathaway track

was actually produced by Rick Rubin, and it was the only song where Justin wrote the lyrics on paper first, then went into the booth.

By the time we were done with the album, I knew that we had created something special. It felt like Justin was my Michael Jackson and if I had done my job correctly, I was his Quincy Jones. I have to say that I smiled when I read in the *New York Times,* "Brave enough to give himself over to the daredevil producer Timbaland, Mr. Timberlake was rewarded with a twitchy, audacious electro-pop album. The hits ('SexyBack,' 'My Love') are monsters, and there are more ('LoveStoned,' 'What Goes Around . . .') where those came from."

*FutureSex/LoveSounds* ended up selling more than twenty million units worldwide. In the first few weeks, *Justified* felt like such an insurmountable hurdle. But only when we let the numbers go, stopped worrying about sales and just started thinking about love and sex and the music—Prince, Bowie, Michael Jackson, Donny Hathaway—that we loved, were we able to create something that felt so right and did so well.

After working with Justin, I felt pumped and prepared to go back and tackle something that felt like unfinished business in my career. Beat Club, my label with Interscope, had failed. But I was coming across a lot of talent that I wanted to nurture and I felt like it was time to start a new label. So I started Mosley Music Group.

Just because something doesn't work out the way you want it to the first time around, that doesn't mean it never will. My first shot at running a label didn't work out. But if I had given up and never tried again, it would have been a

tragic mistake. There's no giving up in this world. You keep pressing on until you make it.

After so many years of working with talent and hearing good music, I knew I had what it took to put my own artists out with some level of success. Despite earlier disappointments, I took the lessons I learned from the Beat Club imprint and put all of my energy and all that I had learned into making the Mosley Music Group a success.

# 20

# MY INTERNATIONAL FLOW

Björk. The one-name Icelandic wonder wanted to work with me. I was honored and excited. I'd been paying close attention to her sound for a long time. When I was starting out as a producer, *Debut* was an album I played in heavy rotation. The album had been produced by Nellee Hooper (known for his work with the Brit group Massive Attack), and it was the kind of genre-defining work that made my heart pound. The first single, "Human Behaviour," was an electronic dance hit with a sample by the Brazilian artist Antonio Carlos Jobim. "Venus as a Boy" had a Bollywood vibe to it, and there was even a classical-leaning cover of the great jazz song "Like Someone in Love." Needless to say, I couldn't wait to see what we could brew up together when the boy from the VA met up with the Icelandic dance queen.

In 2007, we met at the studio to discuss the direction she wanted to take with me. I asked her the question I asked all of my artists: "What are you trying to achieve with this album?"

She was shy but spoke confidently, with a heavy accent: "I want it to be full-bodied and really upbeat."

"Well, how do you hear the beat in your head?" I asked.

"Here's what I don't want," she said. "I don't want commercial and I don't want hip-hop. I didn't bring you on because of your success with hip-hop and pop. I brought you on because I respect your artistry as a musician—period."

Björk went on to explain that she had told a reporter that she wanted the album to be upbeat and that her fans were already speculating that this album would be more pop than the others. Even her label was predicting, and hoping, that this would be the most commercial thing she had ever done. The very thought of that kind of pressure clearly filled her with worry.

"That's not what I want," she said. "I want to remain true to what I've always done while still having the room to grow. Do you understand what I'm saying?"

A producer is, in some ways, also a therapist. You have to really listen to where the artist is at emotionally and help him or her create this virtual ladder, through notes and samples, lyrics and melodies, that takes them creatively from where they've been to where they want to go. I thought about Justin and Nelly Furtado and how they each had the challenge of expanding their musical boundaries without alienating their core base. I truly felt like I could do the same for Björk.

For a while, we were stuck. By now, you know how common that is. She wrote lyrics that she wasn't feeling. I made beats that ended up on the cutting room floor. Then one day,

Björk came into the studio, excited about a dream she'd had the night before.

"Okay, are you with me?" she asked. "I mean, really, really with me? Because this is far-out."

"Let's hear it," I said.

"In my dream, I was on a cross-Atlantic flight to New York," she began. "There was a tsunami and millions of people were suddenly high above the airplane. The wave from the tsunami eventually completely overtook the plane. Then we went into free fall and landed right on top of the White House. And the White House was completely obliterated. Somehow, I want the song to capture my dream. That sense of drama."

"You want chaos," I said, nodding my head.

She smiled. "That's exactly what I want. A quite chaotic song. Lyrically, it will be a collection of all these images from that dream. I was haunted by it. Have you ever been haunted by a dream?"

I nodded, although I didn't want to waste our valuable studio time by explaining. The horrible dreams I suffered after Aaliyah's death. The way that sometimes it feels like I'm haunted by musical spirits. There are times when I just want to turn the music in my head off, but I can't. I think that's why drugs and alcohol remain such a stalwart part of our landscape in the music business. It's not because we party so hard (though we do, sometimes). I think it's more that we feel things so close to the bone; the sounds and the music are with us constantly and sometimes we just want to turn it all off. It's like that Rudimental song:

*I drink a little more than recommended.*
*This world ain't exactly what my heart expected.*
*Tryna find my way someway, oh I, oh I, oh I.*

Working with Björk, being able to do whatever I wanted without wondering how it would chart or how the label would receive the music, was so freeing. She wanted chaos and I gave it to her on a track she called "Earth Intruders." I created a space-odyssey beat but I had to work every drumbeat and every piano chord so that they could keep up with her lyrics and her delivery, which were so unlike anything I'd ever worked with before.

"I love this," she said when we were done. "That's what I wanted."

It's what every producer dreams of hearing from the musician he's working with. I live for hearing that I've delivered the goods.

Shortly after my work with Björk, Justin called me about a project he wanted to bring me in on.

"I've only got one word to say to you," Justin said.

"*Sex?*" I guessed.

"You're getting warm," he said.

"*Money?*" I ventured.

"Madonna," he said.

What was he going on about?

"Madonna loved what we did with *FutureSex/LoveSounds*. She wants some beats from you and some lyrics from me for her new album."

I had grown up listening to Madonna. We all had. No other artist had achieved what she had in music, largely

because she never stood still. The music industry always wants you to repeat yourself. They don't title albums as sequels, like *Robocop, Robocop 2, Robocop 3*, but if you listen closely, there's a lot of that in the production of hit albums, especially in the nineties and early 2000s. A musicologist named Susan McClary said about Madonna's music that it "refuses stability, remains fluid and resists definition." That very notion of constant creativity and constant change has been intrinsic to the DNA of my own music from day one.

So I found myself surprisingly reticent when Justin called. What if I wrote a track for Madonna that didn't make the album? What if I wrote a single that failed to chart? This was Madonna. It was time to go big or stay home. Part of me was inclined to stay home, and I told Justin so.

"I know that's not *you* doubting yourself, Tim," Justin said. "You? The one who is always telling people to believe and have faith? You're telling me that this can't happen?"

He'd called me out. That's what brothers do.

"Listen," he continued. "She wants to work with us. She's getting some beats from Pharrell too."

"That's hot," I said. I was always pleased to hear that Pharrell was in the mix. His successes felt like my success and inspired me to keep on my path.

I don't usually trip over celebrities. But I had to admit it: working with Madonna would be a big deal. She was one of the biggest stars in the world and her mark on music was undeniable. I was excited to even be in the running to contribute to her new album.

Justin told me that he'd get back to me, but the very word *Madonna* was like a shot of musical adrenaline. I went right

to the studio and stayed up all night, grooving and making music that I thought she might appreciate. I wanted to take her back to her "Lucky Star" era, when fun was the order of the day and all anyone cared about was just doing good music.

Madonna was on the verge of signing a ten-year deal with concert promoter Live Nation that would be a groundbreaking 360 deal encompassing all of her albums, merchandise and touring. I wanted to make sure that she started that deal on the right foot. I wanted her last album with Warner Bros. to be a banger.

Justin and I flew to London to meet with Madonna and talk about the album. When we walked into the studio to meet her, she was plain and direct.

"I want some hot shit," she said.

Justin and I laughed.

"No other direction?" I asked, smiling.

"I already like what you two have done together," she said with a shrug. "I know you have what it takes to give me the sound I'm looking for. Just make it hot. That's it."

And just like that, she was gone.

I thought Madonna would be your typical type A workaholic, asking us for a thousand options and riding us through the night until we came up with something that was acceptable to her. My experience with her couldn't have been more different. She works hard when she's in the studio. She's got her yoga folks and her gurus and she's very hands-on with her kids. So Justin and I had to work hard, but we also had to work fast. She wasn't one to be sitting around the studio, making jokes, eating and laughing. She had a job to do, and she came in daily and did it.

While Madonna wrote with Justin, I worked on the production. We ended up writing ten songs for Madonna and I'm proud of all them. One of my favorite tracks, a song called "La La," didn't make the album. It was so off center that the song didn't even have a hook. But "4 Minutes" was the banger that changed the game. Madonna and Justin decided that they wanted to write a song about how we could save the earth and still have a good time while doing it. The idea being you've got just four minutes to grab the person you love and save the world.

I knew the beat for a song like that should be fast and furious and showcase a sense of urgency. The song had been inspired by Madonna's trip to Africa, where she would go on to do a lot of work with the people of Malawi. She had been changed by that experience and the song showed how quickly one can be inspired to take action for good. I layered the song with elements of classic funk songs: marching band sounds, horns and some of my favorite entries from my catalog of sounds: bhangra beats, foghorns, ticking clocks and cowbells.

For me "4 Minutes" was also a kind of wink to the idea that the perfect pop song is three minutes long. The first 78s that were produced in the early 1900s could only hold three to five minutes of music. In 1949, when RCA released 45s, they could only hold about three minutes. Radio stations would only play songs that were three minutes and fifteen seconds max. In 1964, when the Righteous Brothers released "You've Lost that Lovin' Feelin'," the song was three minutes and forty-five seconds long. Phil Spector, the legendary producer, stamped the length "3:05" on the record's

labels so DJs would play it. A great three-minute pop song is like a Rubik's Cube that a producer has to solve and re-solve every time he or she steps into the studio.

"4 Minutes" was the first single of Madonna's *Hard Candy* album and I was proud of that. It meant that the label believed it was the song on the album that best defined the direction of the artist. It also meant that Madonna felt the same way. I was grateful for that.

Around the time that I first started working with Justin, I got a call from my friend Polow da Don, a rapper and producer based in Atlanta.

"There's a girl down here that you've got to meet," he said. "She sings. She writes. She's the total package."

"Sounds good," I said.

"Hold on a second . . . ," he said.

There was a bit of noise and static on the other end. I waited and then a light and airy voice came over the phone.

"Hey, Tim," she said. "It's Keri Hilson."

"What's up?"

"Polow wants me to sing for you."

"Over the phone?"

"Yup, over the phone. If you like what you hear, maybe you can come down to Atlanta and hear what else I've been working on in the studio."

I liked her gumption. It reminded me of Missy and her girls waiting for Jodeci so she could sing for DeVante.

"Well," I said, "let's hear what you've got."

I really wish I could remember what Keri sang for me on the phone. All I know is that I was ready to jump on a plane or get on my tour bus to see what she could do in person. She

had the perfect sound for a pop/R & B star. It was light, not aggressive. She was forceful but not over the top. Honestly, her voice reminded me a little bit of Aaliyah. As soon as I heard her voice, I knew I was going to Atlanta and that one day, I was going to work with her.

It took a couple of years, but one of the first acts I signed to the Mosley Music Group was Keri. At just twenty-two years old, Keri was a founding member of an Atlanta-based songwriting collective called the Clutch. Together with her songwriting team, she'd already written a handful of hit songs for great artists: "Take Me as I Am" by Mary J. Blige, "Ice Box" by Omarion and "Break the Ice" by Britney Spears.

I had put Keri on a few tracks myself, trying out her sound and using her voice to bolster the tracks I was working on. Keri proved early on that she was a hard worker. When I asked her to come to the studio, she was there. Her experience as a songwriter helped her to create unique hooks and background vocals as well. One of the first tracks I put her on was an underground hip-hop classic called "Hey Now (Mean Muggin)" by Xzibit. The beat was high energy and unrelenting with the sounds of finger snaps throughout. It was like a basement party that went till morning because everyone was dancing so hard and having so much fun that nobody noticed the sun was coming up. Keri found just the right tone and groove to go with Xzibit's flow and in the video she brought her beautiful street-smart-but-still-glamorous tomboy energy, which complemented the mood of the song perfectly. It was obvious that she had star quality and star power. I was happy to play a role in her transition from songwriter to singer.

After the Xzibit cut, I put her on a song called "Let Me Luv U" on Chingy's album *Hoodstar*. This track was ultra-fast and Keri used her voice at a higher register, showing her vocal diversity. I always like to work with a singer who can bring range to the table. I used a lot of high hats and whistle sounds to add to the ethereal, almost space-jam-like mood of the song.

Day in and day out, I kept telling anyone who would listen that Keri Hilson was the joint, that they just needed to hear her voice. We were both thrilled when Diddy agreed to make Keri the featured vocalist on a track called "After Love" on his *Press Play* album. Keri was still so young, but you could hear her growth, track after track. She was bringing elements of Gladys Knight, elements of Diana Ross, a little bit of Sade, and yet each and every time, she sounded wholly and uniquely like herself. We were still a couple of years away from releasing her solo album, but landing those feature spots on songs with established artists is the best way to release a new artist. From hearing her on the radio to seeing her in music videos, the public was starting to wonder, *Damn, who's that girl?* And creatively, Keri was learning and growing from the experience of working with a wide range of established heavy hitters who all brought something different to the table.

I also did a remix for Beyoncé's song "Get Me Bodied," which was really fun. I love working on a remix because it takes me straight back to those high school days when I was DJ Timmy Tim, learning how to spin tracks at community center parties. I loved Beyoncé's energy in the song and the "I'm gonna do me" vibe in her lyrics:

*I ain't worried doing me tonight*
*A little sweat ain't never hurt nobody*
*While you all standin' on the wall*
*I'm the one tonight*

Getting back in the groove of producing was inspiring. I started playing around with the idea of an album of my own. I had done solo albums before, with varying degrees of success. But it had been a long time and there's always the fear of failure. Producers aren't always successful when they try to go to the artist side. I just wanted to produce an entire album on my own and invite a mix of artists—some known, some not so well-known—to my musical party. After mulling over the idea for a few weeks, I decided to go for it.

I knew right away that I wanted Nelly Furtado, Justin Timberlake, Jay Z, and Keri Hilson on the album. The final roundup for what we called *Timbaland Presents: Shock Value* ended up living up to its name. I think I surprised a lot of people with the eclectic group of artists I put together. I reached out to Pete Wentz and Fall Out Boy for a track called "One and Only." I love Pete's music and I didn't care that he doesn't fit into the so-called urban music that I'm typically associated with. Similarly, I've loved Elton John since I was a kid. "Tiny Dancer" is one of my desert island discs for sure. When he agreed to record a song that I wrote called "2 Man Show," I just about lost my mind. It was such an honor to be in the studio with him. He recorded his piano solo in just one take. Listening to him play, seeing the way he moved his body over the keyboard and closed his eyes, I

felt like I was being taken to church. I told him that, and he said that was a good thing because gospel had been such a huge influence on him.

After he left, I just played the riff over and over again and I thought about the kid I had been, living in subsidized houses in Virginia, roaches everywhere, holding on for dear life to my most treasured possession, my little Fisher-Price record player. For so much of my early years, my focus was just on surviving from one moment to the next—getting shot at the Red Lobster, me and Missy hiding from gunfire the night that gang mistakenly attacked our friend's house, sleeping next to the heater in DeVante's basement wondering if I could scrape together fifty cents to buy myself a pack of ramen. How could I have known that one day the thing I loved to do—collect sounds, catalog them in my brain, then lay them down on tracks—would lead me to a private audience with someone like Sir Elton John.

**IN 2007, ONEREPUBLIC** was the first full-on rock group to be signed to my label. I was feeling the group, five guys from Colorado Springs, when they were unsigned and popular on MySpace.com. I liked their sound and I wanted to work with them. When I got the opportunity to sign them to my label, I didn't hesitate.

OneRepublic was getting slept on in a major way, yet I knew there was something there. Their vocals were smooth and soaring and the band members were true musicians. They came studio-ready from working on their music independently for so long. One of the first tracks we worked on

was a ballad with a lot of punch. I brought a deeply layered integration of beats and Ryan Tedder, the group's lead singer, met me—note for note—with his streaming falsetto. The result was a hard-hitting love song called "Apologize." It would go on to be the biggest song on their debut album, breaking all kinds of records. But that didn't matter to me. What mattered was that people were still feeling me. I'd overcome so much and come back out on top.

When I went on tour with Justin for his *FutureSex/Love-Sounds* album, Rihanna was the opening act. We all ended up getting along really well. Even when we weren't performing, we hung out together, working on music. When we got to Chicago, Justin and Rihanna started working on a beat together. Then they brought the beat to me. I loved it immediately.

"So what's the inspiration behind the song?" I asked.

Rihanna said, "It's a metaphorical song. We're going to use the idea of rehab as a way to talk about getting over the guy. We have to deal with this relationship like an addiction. We don't want the BS anymore."

Months later, we all met up at Jay Z's Roc the Mic studios in New York to bring together all the pieces of the song that we'd call "Rehab" and get the track ready for Rihanna's next album, *Good Girl Gone Bad*.

Justin had been playing with the lyrics for months in his head. He explained, "It came to me last year, but I just wasn't able to get it down. But I knew all along that I wanted it for Rihanna."

I loved the lyrics he came up with and how little he leaned on traditional rhyme structure:

*Damn,*
*Ain't it crazy*
*When you're loveswept*
*You'll do anything*
*For the one you love*
*'Cause any time*
*That you needed me*
*I'd be there*
*It's like*
*You were my favorite drug*
*The only problem is*
*That you was using me*
*In a different way*
*Than I was using you*
*But now that I know*
*That it's not meant to be*
*You gotta go*
*I gotta wean myself off of you*

Justin sang the song in the studio to reference it for Rihanna. She went in, put her own twist on it and killed it. But Rihanna wanted to do it again. "I want to feel more confident in my delivery," she said. "I feel like on this album I've found myself and I want that to come through my music."

**IT TOOK ME** some time, but just like Rihanna said, I found myself in the music too. It wasn't just about making hits or working with famous artists; it was about the comfort of

being good in my skin, making peace with my past and my present.

The culmination of that process of finding myself came in 2008, when, on the island of Aruba, surrounded by all of our friends and family, I married Monique, as I knew I would from the first moment I saw her. Today, we're raising three children together and I could not be happier. I was never sure that I had what it took to be a good father. But I do. I enjoy fatherhood immensely.

# 21

# BUILDING MY EMPIRE

In 2014, director Lee Daniels and Danny Strong had the idea to tell an old story in a new way: what if you set King Lear in the midst of the hip-hop industry? The result was a show called *Empire*. In Shakespeare's play, the king must decide which of his three daughters will receive his kingdom. The machinations and the drama that ensue drive him to madness. In *Empire,* the king is Lucious Lyon, who started out as a drug dealer on the streets of Philly and, using his prodigious musical talent, became one of the most powerful producers in the music industry today. When he gets a fatal diagnosis, he must decide which of his three sons will run the label he founded, Empire Entertainment. His oldest son, Andre, has a degree from the Wharton business school and is currently the chief financial officer of Empire. Andre is ambitious and hungry, and suffers from bipolar disorder. Hakeem is the youngest son, an up-and-coming rapper and Lucious's favorite. And then there is Jamal, a talented singer-songwriter whose sexuality is a real issue for his homophobic father. If that weren't

enough drama, there's Lucious's ex-wife, Cookie. Cookie took the fall for the drug dealing that provided the seed money for Lucious's label, and now that she's out of jail, she's raising hell and determined to take every dime that she feels she is owed.

From the beginning, I loved that you see where the characters started. You can be living fabulous, but your past culture is going to come up. At the end of the day, a lot of us come from poverty and go from having nothing to building something and having to maintain our dream. It's like Lucious says: "I started selling drugs when I was nine years old in Philadelphia. I did it to feed myself. But it was the music that played in my head that kept me alive when I was afraid I was going to get shot. And it was the melodies that I dreamt about that kept me warm when I was sleeping in the streets . . . Music saved my life." I didn't deal drugs—I've never pretended that's my background—but when you look at a lot of us in this business, from me to Jay Z to Dr. Dre and Diddy, some part of what Lucious says rings true for us. What a lot of us have in common is we got here by never giving up—we are non-quitters, no matter what the circumstances.

**BY HIS OWN** admission, Lee says that musically, he's "stuck in the world of Diana Ross and Donna Summer." When he asked his kids, "Who's the hottest producer out right now?" they said, "Timbaland." So he brought me in as executive music producer. I'd never worked on a television show before, but it has been an amazing opportunity to work with talented people outside of my field as well as

to put a visual—scenes on screen—to the work that I do behind the scenes, which the public rarely gets to see.

In the opening scene of the series, the very first thing you see is Lucious (played by Terrence Howard) in the studio with an up-and-coming artist whom I have been working with for over two years, a young woman named Veronika Bozeman; she goes by the name of V. She is a beautiful woman with a completely bald head, eyes that are as big as saucers and lips that are every bit as luscious as the voice that comes out of them. In the scene, V. is singing, and to the average listener, she sounds amazing. Her voice is melodic and clear; she's doing the little R & B riffs that made singers like Mariah Carey and Whitney Houston into superstars. But Lucious knows that V. is holding back. He stops the session and tells her, "I need you to sing as if you are going to die tomorrow. As if this is the last song you will ever sing, you hear me? Show me your soul."

When Lucious confronts V., she is visibly annoyed, but the scene rings true, because I've had that conversation with an artist not once, not twice, but hundreds of times. It's so hard to pinpoint the magic, hard to dissect what happens in a recording studio, hard to say what will make a song a hit that is played all summer long, what will make a song a classic that will last and be loved for years or even decades. But I can say that part of what makes a song a hit or a miss is that conversation that Lucious had with V.—the very same conversation that I have with the artists I work with. Talent is irrelevant once we sit down and do the work. By the time most artists get to me, they know they can sing. They've won all the talent shows. They've done the equivalent of *American Idol* or *The Voice* or whatever competition got them to the

point where they could get a deal. They know how to sing. They know how to show off. But to take all of that ego and protection off? To sing as if they were dying and their life depended on it? That's another matter entirely, and it is not something everyone can do. It's my job to push an artist. To get beyond what sounds good to the point of what is real. Lee Daniels and Danny Strong came to me to create music for the show, and the soundtrack has been successful, debuting at number three and selling a volume of music that it took shows like *Glee* years to achieve. But it's the insight that I can give from working with so many artists that I think makes the story feel so authentic to both viewers at home and industry vets who praise the show for being so real.

**EARLY ON IN** the shoot, Monique and I visited the *Empire* set in Chicago. Monique was dressed to the nines in a Chanel runway lace blouse, a Balenciaga skirt and some seven-inch Christian Louboutin heels with spikes on them. Lee took one look at her and said, "Hunty, this is what I imagine Cookie looking like." So he hired her as a fashion consultant. I love that the show is now truly a Mosley family affair. Although she has an MBA and her business savvy is through the roof, my wife has always had an amazing sense of fashion.

It's been said that clothes let you tell the world who you are without your having to say a word. From the beginning of our relationship, Monique said to me, "You deserve to be dressed by fashion houses when you walk on the red carpet." I'm as healthy and as cut as I've ever been now, but my weight goes up and down, and although a lot of men don't like to talk about

it, it's hard to get nice clothes when you don't fit the samples the designers make. Monique went right to Frida Giannini at Gucci and they made me a custom suit. I got to pick out the materials, the way it was put together, everything. I'd never had an experience like that before and she made it happen. It's just clothes, sure. But being dressed to the nines gives you a certain level of confidence that I'd never had before.

**I ALSO SEE** my kids in *Empire*. I think a lot about them and the legacy that I'm creating for them. Frankie is a pure athlete; everything is about basketball for him. We had a beautiful tennis court behind our house, and that boy took down the net, installed two hoops and turned it into a basketball court. Did I mention he's twelve years old? He's not musical but I love that he's got that will and determination from me and Monique.

Demetrious, our eldest, is nineteen. He's got that creative gene 100 percent. He writes poetry. He taught himself to play the piano. It's exciting to see him explore and find his own voice. At his age, I didn't yet know what a Timbaland song would truly sound like. I was still DJ-ing, just starting to write, working with Missy, building my musical foundation and preparing for all that was ahead.

My youngest, Reign, is a born performer. She loves to crawl into bed with me, and I'll beatbox while she freestyle rhymes. A few years back, we made a little video of her freestyling over my beats and Missy tweeted, "Reign down going platinum!" Someday I know we'll see that for sure.

One afternoon, just a few months ago, Monique and I were upstairs in the house and we heard the most beauti-

ful song coming from the baby grand in the living room. We looked at each other and smiled. I said, "Wow. That's beautiful. I never heard Demetrious play that song before." I went downstairs and it was Reign. She was just sitting at the piano, freestyling on the keys, the way she freestyle raps. She said, "Oh, Demetrious taught me a few notes and I'm playing around." I think she hears the world the way I do. I can see the way when she hears a particular sound, she pauses as if to mentally record it for future use.

Recently, I was working with Zendaya, who's a big Disney Channel star looking to transition into a more grown-up sound. Zendaya is eighteen and of course, Reign is a big fan, so I FaceTimed her from the studio.

Reign said, "So how do you like your career?"

Zendaya was so taken aback. She said, "What? How old are you?"

Reign said, "I'm seven. I'm thinking I might want to do what you do. So how do you like your career?"

I love that Baby Girl is so business-minded but I want her to be a kid for a while longer before she gets exposed to the industry. I don't believe in stopping any of my children's dreams, but I do want to protect their childhood.

*EMPIRE* **REALLY SHOWS** how powerful music is. Music can make you be wherever you want to be. If you're scared to talk to a girl, you might put on a Miguel song. That song might give you the courage to talk. Music gives you the ability to do what you think you can't do because it's like a friend talking you through your highs and your lows.

It is so great to have the constant flow of creativity we have on *Empire:* the jealousy, the envy, the prosperity, the doubt, the ego, the confidence—I pour it all into the music. We'll get a script in late, and they'll need a song by the next day or the day after. There's no time to think too much about anything. It's an adrenaline rush. I'm still learning how it works. It's a good thing in the creative business to be thrown into something so new, you've got to start from scratch and learn a new style, a new format, a new pace and a new flow. I've got a great relationship with Brian Grazer, who is an executive producer on the show, and Lee is letting me be free—letting me translate the words into music and emotion. It helps that I have a team of great people, including my star player, Jim Beanz—he writes a lot of the music with me.

I call my songwriting and producing Team Timbo. They're like my X-Men and I'm Professor Charles Xavier. I let them know that the music isn't in the equipment; the music has to live in you. I can give anybody off the street a computer and say, "Make a beat." I can take the hottest producers in town and throw them in a room with all that equipment, and everybody can make a beat. But let's take the equipment away, let's take the computers away; I can make beats all day with nothing electronic at all. A lot of these kids don't know about yesterday. They sample a classic and they think they stumbled on it. But it's not enough to just flip an old sound and make it new. You've got to feel the music in your bones for the whole world to feel it too. Say what you want about R. Kelly but he is a genius. In songs like "Your Body's Callin' " and

"12 Play," he invented ways to love on a black woman. You can be nitpicky and say that he wrote twenty songs on a single progression, but that one group of notes will resonate in your soul.

**I'VE GOT A** label partnership now with Epic Records chairman and CEO LA Reid. I'm producing a twenty-year-old girl named Tink who's going to bring things back to the days of Lauryn Hill and Missy Elliott—girls who gave you substance the way Biggie Smalls and Tupac did. And I'm excited to put out even more music from V. Bozeman. Both she and Tink are on my album, *Opera Noir,* which is like nothing you've heard before. What I'm trying to find are these young people who have the same hunger and passion I once had and still have, and pass it on to the future. I feel I can be a mentor and help make new music that will break through some of the garbage. When music starts to fall off the path with dumbness and flashiness, well, it's my job to set a tone, a foundation. If you want quality music, come up on the Timbaland side of the street. I don't spend a lot of time looking at what I've done in the past; I look at what I'm setting up for the future. I feel like every six years the greats kind of revamp themselves—and for me, *Empire* is like the first step of my reinvention.

The show kind of snuck up on people, but what I think the producers understood from the beginning is that black people matter. Black people have shaped American culture. All we ever needed in order to create was our hearts, our creativity and the right platform. I think all of these award

shows are crap. It's all about seeing the clothes, how people are dressed. You can't give me an award for how my music makes people feel. That's why I can honestly say that *Empire* is the best award. Watching black history on-screen, seeing how black people evolve, that's the reward.

**THE GREATEST GIFT** of this career is that the groundwork I've laid means that I'm not auditioning anymore. I've created more than fifty Top 40 hits over the last twenty years. I've got a body of work that not only speaks to what I've accomplished in the past but also gives people the confidence to let me try things that might be entirely new to me.

Do I feel like I've hit my ceiling yet? By no means. As well as I've done, I still don't feel like I have all of the accolades, all of the awards, that I should have. My goal is to achieve a body of work that can sit in comparison with the work of the one and only Quincy Jones. That's the level I'm aspiring to. And I'm not there yet. Until I get there, I've got to keep working. I've got to wake up every day and say, "You're still the underdog, Tim." I produced my first big hit in 1996 at the age of twenty-four. Next year, I'll be forty-five. Over the last twenty years, artists have come and gone, come and gone. I'm still here.

From the very beginning, the love of music has been what has driven my happiness: from my dad playing Rick James and Prince on Saturday afternoon to the singing and swinging and getting merry like Christmas with my mother and her church folk on Sundays. In her book *A Return to Love,* Marianne Williamson wrote words that have given great confidence to creative people the world over:

Our deepest fear is not that we are inadequate. Our deepest fear is that we are powerful beyond measure. It is our light, not our darkness, that most frightens us. We ask ourselves, Who am I to be brilliant, gorgeous, talented, fabulous? Actually, who are you not to be? You are a child of God. Your playing small does not serve the world. There is nothing enlightened about shrinking so that other people won't feel insecure around you. We are all meant to shine, as children do. We were born to make manifest the glory of God that is within us. It's not just in some of us; it's in everyone. And as we let our own light shine, we unconsciously give other people permission to do the same. As we are liberated from our own fear, our presence automatically liberates others.

You may be thinking, *I'm not musical, I'm not artistic, I'm not creative,* but we are all makers in this world. We make businesses and we make families. We make communities. We make meals. We manufacture peace, hope and understanding in our hearts and our actions. We make love—in every sense of the word. And if it's true that sometimes we make a mess—Lord knows, I've made my share—we are also blessed with the opportunity of second chances; there's always a chance to grow a little and clean our messes up.

Music has long been known as a young kid's game, but I've been happily surprised that even in my forties, surprises keep coming. I've stopped planning and worrying, maneuvering and manipulating. I'm just doing the work. I can honestly say that my workday is a happy loop of a routine that fills me with purpose: Rise and grind. Give thanks. Show up and listen. Make music and give back. Hold my loved ones dear. Then I hit repeat.

# TIMBALAND'S RULES FOR COLLABORATION

**M**any people think that the music business is so unlike any industry that its rules just don't apply to any other business. I disagree. Business is business. And whether you're at Apple, designing the next iPhone, or you're at an advertising agency in Kansas City, coming up with a new marketing campaign for a client, or you're in Miami, opening a brand-new hotel, creative collaboration is what's going to take you to the top and keep you there. These are my rules for creative collaboration.

## 1. When, Not If.

From the moment I met Missy Elliott, she has been an unyielding fountain of optimism. She always believed that we would get a record deal, that we would achieve all of our goals creatively and professionally, and she never wavered. Now, let me be clear. Missy did more than hope. She worked her ass off. We both did. There's an African proverb that says one must move one's feet

while one prays. Whether you're creating with just one team member or dozens, make sure you're all on the same page. Does everyone believe in the project with as much heart and soul as you do? And the next question is: is everyone willing to work day and night to make what is only a dream come true? If that's the case, then there's no telling what you can accomplish.

### 2. Pay Your Dues. But Don't Be Used.

I stayed too long in the world of DeVante's Da Bassment Crew. But I paid my dues. When you're assessing your own experience, ask yourself—how can I beef up in this one particular area, in a way that makes me grow but doesn't make me feel used?

### 3. Every Team Needs an Experienced Industry Vet with Heart and a Talented Rookie Willing to Take a Risk.

For us, early on, our industry vet was Jimmy Douglass, the in-house studio engineer at Da Bassment, who helped me escape that situation and sign my first big deal. And of course, the talented rookie willing to take a risk was Aaliyah. Who do you have on your team and in your life who can play the same roles? Every great creative venture needs the weight of experience and the lift of someone who is young enough and green enough to do something totally new.

### 4. Listen More Than You Talk, Always.

Some of the most important work I do with artists are the conversations we have before I lay down a single beat. I love to talk to creative people and hear what's going on in their

lives. Are they in love or out of love? Do they have a favorite painting that moves them to tears, even though they don't know why? Did they read an article or is there a political issue that has them fired up? What were their favorite songs as a kid? What music did their parents listen to? I always do more listening than talking. And sometimes while they talk, I respond by tapping out beats with my hands—the same way that I did in high school. In school, the tapping got me in trouble. But in the studio, the artists understand that it's almost like I'm a talking drum—the beats I'm making are my way of responding, the response in a very traditional, almost tribal, call-and-response pattern. It's a natural thing to talk a lot and to speak quickly when you get nervous, but if you're going to create something original, if you're going to collaborate with another person or a group of people, then you have to stop talking, put all the technology down and listen in a way that is deep enough and present enough that you make a connection. That connection is the foundation of the work you'll do together, and when there's magic in that connection, there's no limit to what you can do. The poet Nikki Giovanni once said, "Language is a gift, but listening is a responsibility."

## 5. No Experience Is Wasted. Bring Your Whole Self into the Room.

You can hear my whole life in the songs that I've made, from the toys that I played with as a kid to the trials I went through as a young man to the people and places that make me the man I am. When I first started DJ-ing, I developed that warp style of making beats, where I'd leave a record

out in the sun and let it warp to give it a strange, distorted sound. That sound evolved into all of the futuristic beats that I created for artists like Missy, Justin, Madonna and Björk.

What have you learned on your creative journey? How can you carry a skill, a technique, an idea that brought you energy and joy, into the work you're doing now? Study your successes and look for things that you can replicate.

## 6. Know What Makes You Different and Work It.

Ever since we were high school kids making beats in my bedroom studio in the VA, Missy and I have always known what made us *us*. We never tried to pretend that we were anything besides goofy creative types who could have been art school students just as easily as we ended up being hip-hop artists. We love it all: opera and electronica, rock and reggae, pop and jazz. You can hear us on every single track we produce, even if we don't speak a word. We've always embraced what makes us different and we work it, on song after song, track after track. What's your creative DNA? What makes you uniquely and totally you?

## 7. Respect Your Instrument.

A lot of us let ourselves go when we're in the creative hunt. We work all night. We eat junk and drink too much. We don't sleep and we think, *I'll do better when I'm successful*. What I've learned over the years is that my best work comes when I'm taking the best care of myself that I can. Respect your instrument. Even if you're not a musician,

your instrument is *you*. Like LL Cool J told me, "Get your health right. Everything else will fall in place."

## 8. Don't Prejudge Your Collaborators.

It's a mistake to judge a collaborator based upon superficial aspects like race or skin color. But it's also wrong to make the kind of judgments we do all the time about the way someone dresses or the kind of work they've done before. If you're creative, you don't want to be put in a box. So don't put other people in a box either. If I'd dismissed Justin Timberlake as a boy-band wunderkind, not only would we have never made the music we made together, I would have also missed out on the chance to develop one of the most powerful friendships I've ever known. Sure, do your research about people. Look for markers of talent and excellence. But if you find yourself assigned to a project with someone who, on the surface, seems to not be your type of person, give them a chance. You might be surprised to find that you can do great things together—and if nothing else, you'll grow in the process if you observe and learn from your differences.

## 9. Use the Whole Box of Crayons.

Throughout my career, I've been deemed a hip-hop producer, but musically, I never put myself into the box of any single genre. My love of music from rock and electronica to world music and classic R & B has influenced my work with a range of artists, including Missy, Justin and Nelly Furtado. There's not a business in the world that can't benefit from looking at

what people are doing in other industries and other genres. If necessity is the mother of invention—and Lord knows, when I've needed to come up with a banging beat, I've done it—then diversity is the papa of invention. Broaden the palette of colors at your disposal and you'll watch the creativity of your team soar.

**10.**

My last rule needs no description because it's straight from the mouth of my beloved baby sister, Aaliyah: Try again. If at first you don't succeed, try again.

# ACKNOWLEDGMENTS

A special thanks to my Lord and Christ for giving me this incredible life and a wonderful family.

Thanks to my beautiful wife, Monique "Moe" Mosley. I'm super proud of you! You have put a lot of work into running the Mosley brands, and your efforts never go unnoticed by me, even when you think they do. You are one of the smartest women I know (maybe that's why you can get on my nerves sometimes. Lol!). Thank you to my kids—Meechie, Frankie, and Reign. Without all of you, there is no me.

Thanks to my mom and dad for raising me right. Thank you, Dad, for being my hero and for showing me how to be a man, when most men don't have that. Mom, you are my queen. Thank you for teaching me about God and for always supporting me and my dreams. Thanks to my brother, G, the best brother a brother can have. We've come a long ways. I'm always here for you. Grandmom, thank you for your unwavering love.

Thank you to the rest of my family—I love you all: Aunt Pat, the best aunt; and Michelle, Marcus, Eric, Lance, Rick, Von, Allen, Richie, "Freestyle," Eytan, Mike Daddy, and JT. Man, I could go on and on. If there's anyone not mentioned here, you know me and you know what you mean to me.

A big thanks goes out to the writing team and my publisher, HarperCollins. Veronica Chambers, you have done an amazing job of taking my words and delivering Timothy Mosley unscripted—the past and present. Thanks to Ryan Harbage, my literary agent; and to Tracy Sherrod and Laura Brown, my editorial team, for texting, calling, and harassing me and Moe with deadlines. I also appreciate Dawn Palmer for being of invaluable assistance in pulling this book together.

A heartfelt thanks goes out to my fans and readers. I love ya'll. I hope you get a good look at this misunderstood producer from Virginia. This is just part one of what I want my life to represent!

God bless!

# ABOUT THE AUTHOR

Timbaland, born Timothy Z. Mosley, has played many creative roles throughout his celebrated career. He was a member of DeVante Swing's Da Bassment crew and is one half of the hip-hop duo Timbaland & Magoo. Considered one of the most successful producers in music history, he is the executive music producer of Fox's runaway-hit television show *Empire*. The CEO of his own label, Mosley Music Group, Timbaland lives in Miami, Florida, with his wife and children.